THE ILLUSTRATORS

Raymond Briggs

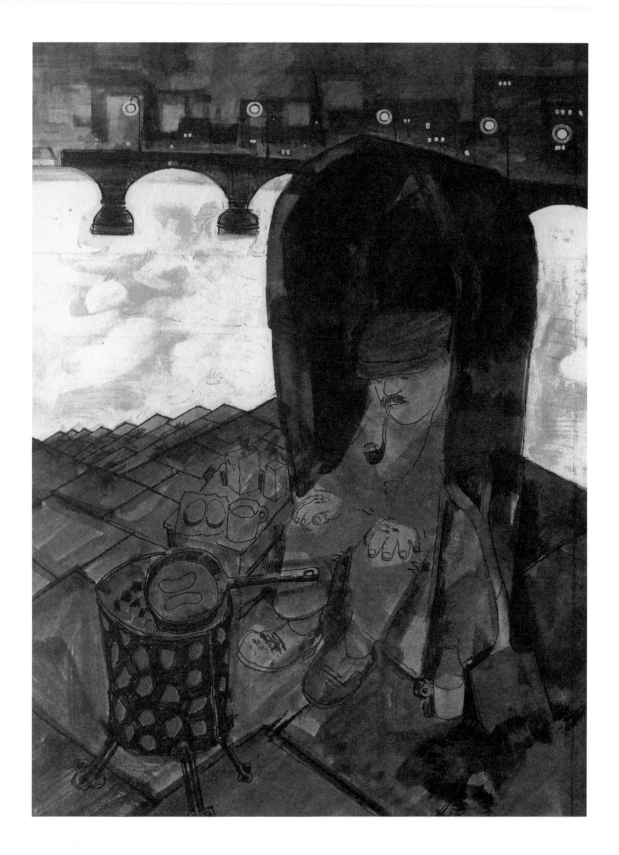

Nicolette Jones

THE ILLUSTRATORS

Raymond Briggs

SERIES CONSULTANT QUENTIN BLAKE
SERIES EDITOR CLAUDIA ZEFF

WITH 107
ILLUSTRATIONS

FRONT COVER Illustration from *The Snowman*, 1978
BACK COVER Raymond Briggs, 2011,
photograph © Jonathan Brady

FRONTISPIECE Illustration to 'London Bridge', *The Mother
Goose Treasury*, 1966
ABOVE A is for Alligator
PAGE 112 Illustration from *The Snowman*, 1978

For Raymond Briggs,
his parents,
and mine – NJ

First published in the United Kingdom in 2020 by
Thames & Hudson Ltd, 181A High Holborn, London WC1V 7QX

First published in the United States of America in 2020 by
Thames & Hudson Inc., 500 Fifth Avenue, New York,
New York 10110

Raymond Briggs © 2020 Thames & Hudson Ltd, London

Text © 2020 Nicolette Jones

Illustrations © 2020 Raymond Briggs

Designed by Therese Vandling

British Library Cataloguing-in-Publication Data
A catalogue record for this book is available from
the British Library

Library of Congress Control Number 2020932461

ISBN 978-0-500-02218-4

Printed and bound in China by C&C Offset Printing Co. Ltd

Be the first to know about our new releases,
exclusive content and author events by visiting
thamesandhudson.com
thamesandhudsonusa.com
thamesandhudson.com.au

CONTENTS

Introduction

Raymond Briggs has changed the face of children's
picture books, with his innovations of both form and
subject. Stylistically versatile, he has illustrated some
sixty books, twenty of them with his own text, and first
became a household name in the late 1970s and early 1980s
with a handful of books – *Father Christmas*, *Fungus the
Bogeyman*, *The Snowman*, *When the Wind Blows* – that were
entertaining and subversive and appealed to both children
and adults.

 The refrains of his work are class, family, love and loss.
Nevertheless, his default mode of expression is humour.
Briggs is always funny, and the balance between this and
melancholy is his defining characteristic, though his style
ranges from the romantic to the grotesque, from the fanciful
to the direct.

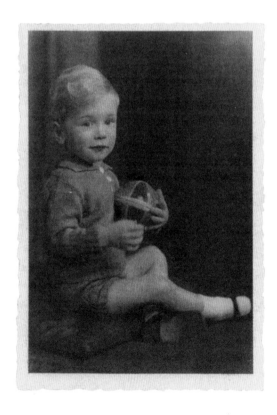

LEFT
Raymond Briggs in infancy

In general, Briggs makes down-to-earth depictions of down-to-earth characters. Lack of pretension is his moral and artistic code. He looks at humble lives, but never *de haut en bas*. His precise and particular observations are revealing and truthful but also compassionate. And he is a chronicler of bereavement. Grief is how his stories end. He has commented – characteristically reluctant to aggrandize himself – that this was just a convenient way to draw a story to a close, but the emotional investment in those endings makes them more than just a device.

Briggs has also been responsible for bringing together two genres that are usually distinct: children's book illustration and the satirical political cartoon. His interest in different social groups makes many of his children's books revolutionary, but he also wrote and drew overtly political books for adults.

Literary journalist John Walsh, writing in the *Independent* in 2012, had this assessment:

> *[Raymond Briggs has] brought to children's literature the trashiness of the comic strip and the vulgarity of Rabelais. He's shown us amazing sights – a nuclear explosion, a close-up of bear fur, a bogeyman in love, Father Christmas sitting on the lavatory. And he has dealt in one activity seldom seen in books for young readers: grumbling. Raymond Briggs is the poet laureate of British grumpiness.*[1]

It is an attribute not only of his characters (notably Father Christmas) but also one he adopted as a public persona himself. Most people who know him would agree that this is a front for his shyness, and a way to be funny. Behind that façade he is generous, kind, obliging and hospitable. He has admitted: 'I have a reputation for being grumpy, so I do my best to keep it up, but it's hard work.'[2] And also conceded: 'I'm always moaning but [am] not fundamentally as depressed as I sound.'[3]

Early years

Raymond Redvers Briggs – he was given his father's middle name – was born on 18 January, which seems to be an auspicious birthdate for children's authors. He shares it with A. A. Milne and Arthur Ransome. Briggs arrived in 1934, nearly four years after his parents were married. Their courtship, as recorded in *Ethel & Ernest* (1998), began with Ethel Bowyer, lady's maid, shaking a duster out of a window in Belgravia, where she worked, and Ernest Briggs, a milkman who happened to be cycling past, waving to her. Raymond grew up in their three-bedroomed Victorian terraced house in Wimbledon Park in southwest London, which seemed very grand to its new owners, as *Ethel & Ernest* reveals, because it had a kitchen, a scullery, a dining room, a sitting room, a garden and a shed, as well as an indoor bathroom and a boiler.

BELOW
An early version of the jacket design for *Ethel & Ernest*, 1998

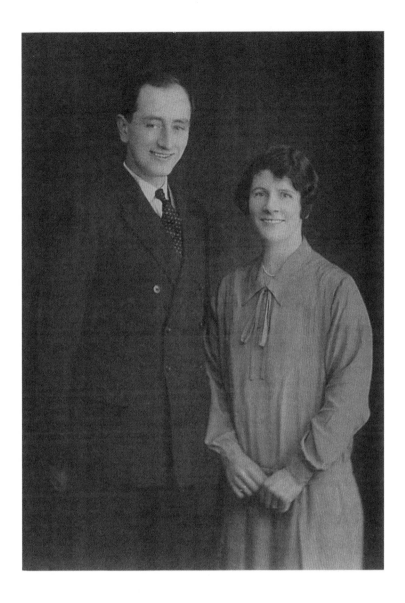

ABOVE
Ethel and Ernest on their
wedding day, 1930

During the Second World War, five-year-old Raymond
was briefly evacuated to stay with his aunts Flo and Betty
in the countryside, at Stour Provost in Dorset, but he was
brought home before long because his mother found his
absence too painful.

In 1945, shortly after the war ended, Raymond won a
scholarship to Rutlish Grammar School, in Merton Park,
where he found himself too weedy for rugby, though his
being there made his mother proud. At the time, in the
wake of a landslide Labour victory in the summer, British

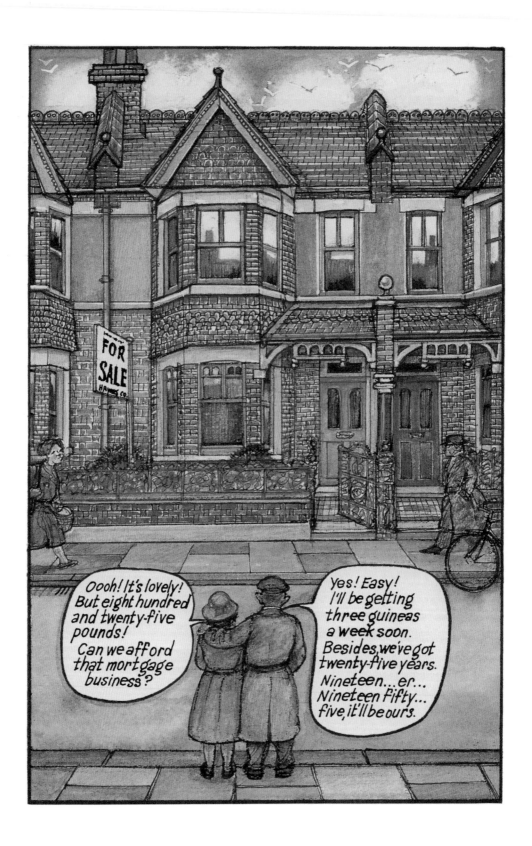

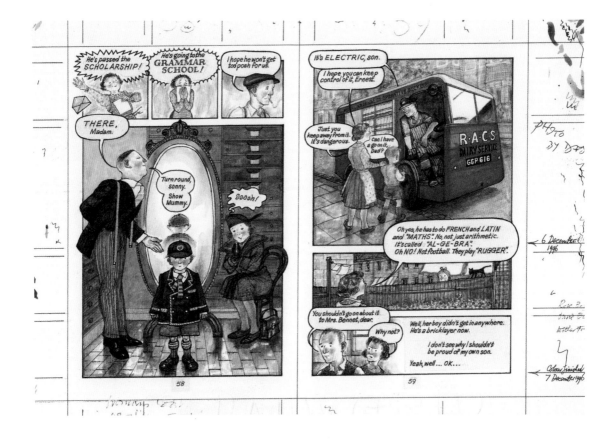

society was still riven by class distinctions, and his aspiring mother thought her son attending a grammar school took their family a few rungs up the social scale. For Raymond, it turned out to be the first of a series of steps that distanced him from his parents. He stepped further away a few years later by going to art school, where long-haired students expressed their creativity in ways his parents found puzzling, and by making a career as an illustrator, which was surely not a proper job. He became part of a world that was increasingly strange to them.

Exploring the gap that opened up between him and his parents became the dominant theme of Briggs's work. It was preoccupying and powerful because he loved his parents as they loved him, their only child, and because, although he rejected some of their attitudes, he also shared others.

Briggs's was not a bookish home, and as a child he 'hated being given books'.[4] Comic strips were his first introduction to art, and at 13 he began to draw, under the influence of

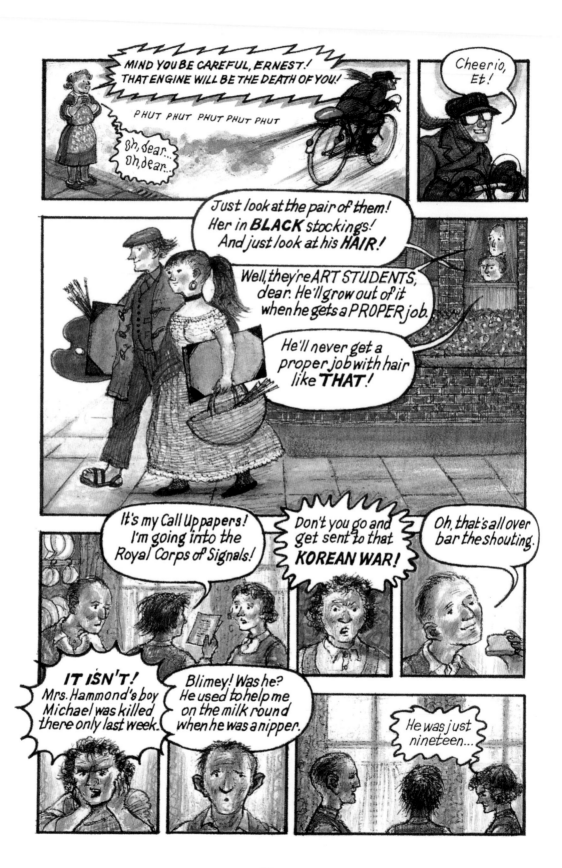

12

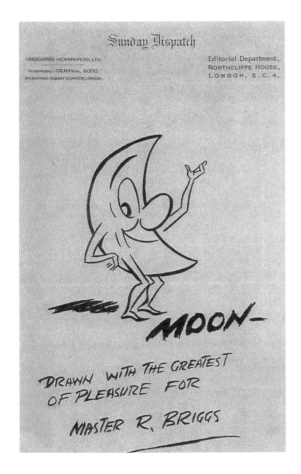

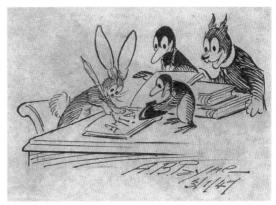

OPPOSITE
Raymond and Jean Taprell Clark
at art school, and Raymond's call-
up, from *Ethel & Ernest*, 1998

ABOVE
Illustration by A. B. Payne, creator
of *Pip, Squeak and Wilfred*, drawn
for Raymond Briggs in 1947

ABOVE RIGHT
Drawing by Sydney Moon of the
Sunday Dispatch, 1947

newspaper cartoonists. Two of them sent him signed images
when he wrote to them in 1947: A. B. Payne, creator of *Pip,
Squeak and Wilfred* in the *Daily Mirror*, and 'Moon' (Sydney
Moon) of the *Sunday Dispatch*.

Briggs has written that in the hierarchy of artistic
esteem, with opera at the top, followed by theatre and then
literature, at the bottom of the heap are, in descending order,
painting, illustration, cartoons and then comic strips. This
was brought home to him at his interview, at the age of 15,
for Wimbledon School of Art, which he attended from 1949
to 1953. As Briggs recalls, when he said he wanted to 'do

cartoons', the interviewer 'went purple in the face and said,
"Good God, is that all you want!"'[5] so Briggs toed the line and
tried to be a painter. 'But,' he has said, 'I don't like oil paint
much – I find it difficult, messy, wet and sticky – and
if you're going to be a painter, you've got to love oils.'[6]
(However, things worked out. In 2012, Briggs was the first
person to be inducted into the British Comic Awards Hall
of Fame.)

Painting was daunting in another way too. Briggs
remembers an exercise at art school when students were
asked to bring their work and hold it up alongside masters
in the National Gallery to make them aware of the tradition
to which they belonged, and to inspire them. It made him,
he says, feel shame at the meagreness of what he had
produced in the context of greatness, and he found it hard to
bear. He held his picture, of a working-class couple sitting
side by side in a pub, which he had thought 'quite rich', up
against Jean-Siméon Chardin's *The Young Schoolmistress*
and found: 'Next to the glowing luminosity and glory of
Chardin, my picture felt small, mean and dirty; almost
disgusting. I felt embarrassed and ashamed.'[7] Briggs's own

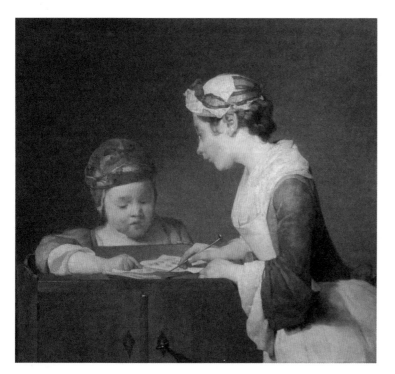

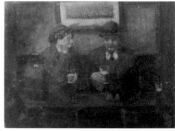

ABOVE
Working-class couple in a pub.
Art school painting by Briggs that
he compared to a Chardin at the
National Gallery, London

LEFT
Jean-Siméon Chardin, *The Young
Schoolmistress*, *c.* 1737, National
Gallery, London

account will always suggest his talent is small, but his work belies this assessment.

After studying at Wimbledon, Briggs went on to a one-year course in typography at the Central School of Art. He then spent two years of National Service in the Royal Corps of Signals – during which he found the comparatively intellectual life of his grammar school/art school background also separated him from his fellow private soldiers (themselves an inspiration for *The Man*) – and he returned to London for two more years at the Slade School of Fine Art, graduating in 1957.

Starting out

Children's book illustration was a way to make a living, and Briggs's first opportunity in the field came when editor Mabel George at Oxford University Press asked him, 'How do you feel about fairies?' The pleasure he found in drawing the fantastical surprised him, and his career was launched with *Peter and the Piskies* (1958), by Ruth Manning-Sanders. The black-and-white images, mostly chapter heads and tails, or page borders, showed pixies, giants, mermaids, witches and devils, rendered with sketchy lines, a dramatic sense of scale, expressive faces and diligent detail.

In the 1950s at art school Briggs met Jean Taprell Clark, a painter who suffered from schizophrenia and lived in the bedsitter next to his. In 1961, Raymond bought a house in Westmeston in Sussex, about half way between London and Brighton, and in 1963 he and Jean were married. Briggs hoped this would give Jean a sense of stability, though he has since said he doesn't like marriage – 'it seems daft to mix up love and the law unless there are children'.[8] Jean's life continued to be troubled, but Briggs has written: 'Schizophrenics are inspiring people. [Jean's] feelings about nature and experiences of life were very intense.'[9]

Briggs taught illustration part-time at Brighton School of Art from 1961 to 1986, a regular source of income for most of his career, and has recalled the informality that characterized academia when he began: 'There was no curriculum, no planning, and there were no meetings. Five

of us, one-day part-timers, went in on different days and never met, despite teaching the same group of students... Over the years, bureaucracy increased remorselessly... Whether the standard of student work was improved by this is debatable.'[10] Part of Briggs's legacy is the encouragement he gave to students. Those he taught remember – belying the curmudgeonly façade again – that they came out of his tutorials 'walking on air'.

One of those students, Chris Riddell (for whom Briggs was personal tutor 1982–84), says Briggs showed his students 'it was possible both to be a satirist and to illustrate children's books. It was not a huge leap because Raymond had shown that the two worlds were merged.'[11] Briggs himself would make no distinction about his audience: 'Books are not missiles, you don't aim them at anybody.'[12]

Early work

Raymond Briggs's early work shows him experimenting with ways of making images. He had illustrated twenty-four books before his *Mother Goose Treasury* (1966) secured him fame. At first his pictures were all monochrome drawings, for short children's novels and for non-fiction books about churches and castles, published by OUP and Hamish Hamilton.

Midnight Adventure (1961), the eighth book Briggs illustrated, had the distinction of being the first he wrote. Unimpressed by some of the texts he had been given, he thought he might do as well himself. At 24, he was staggered to be accepted for publication. The book was based on an escapade of his own youth, when he was brought home by police for breaking into a local golf club. In this story, adventurous boys foil the burglars who break into the golf club. He wrote a second story, *The Strange House*, also based on a memory: of an abandoned house he explored, which had a collection of birds' eggs in cabinets and a tunnel, and two ancient abandoned cars: a Rolls Royce and a Daimler. He would pretend to drive them – a forerunner of a frame from *The Snowman*.

Chapter One

Plans for Midnight

Gerry Martin and his friend Tim Rogers had planned to go out fishing at night, so they were now digging for worms in Tim's garden.

'My it's hot!' puffed Tim, raising his fork in one hand and driving it into the ground like a spear. He lay down in the grass and looked up through the leaves of the apple tree.

'Come on,' said Gerry, still digging vigorously. 'We haven't got half enough yet.'

9

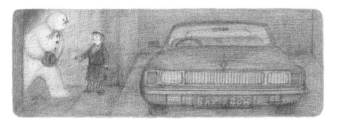

ABOVE

Chapter opener, *Midnight Adventure*, 1961

LEFT

The snowman and the boy pretend to drive. Sequence from *The Snowman*, 1978

The pictures in both books, black-and-white images dark and dense with cross-hatching, are reminiscent of the monochrome work of the illustrious Edward Ardizzone (1900–1979), who was by then celebrated for his illustrations, including for his own *Tim* series. Briggs never just suggests recurring patterns: paving stones, architectural details, railings, fences, trellis, grass, wood grain, the squares on a check jacket and the leaves on trees are all conscientiously represented. Bricks and tiles, each separately drawn, are persistent motifs, as they were to be in the *Father Christmas* books. It is hard to think of another illustrator so dedicated to the detailed depiction of walls. Meanwhile, the figures already have a squarish Briggsian look, the boys with crew cuts, tank tops, shorts and long socks, or belted raincoats with wellingtons, and the villains in flat caps and jackets, or vests with striped pyjamas. This, and the record of playing outdoors, away from adults, makes these pictures period pieces now, but also evidence when Briggs was only a few years out of art school, of a skilled hand.

As an artist, he revealed, even early on, that he could adapt his style to fit the meaning of images with great versatility.

Nursery rhymes

Briggs's first picture book in colour was the nursery rhyme collection *Ring-a-Ring o' Roses* (1962), and it was illustrated with intricate line drawings and watercolours, with a nod to decorative Victorian illustrator Kate Greenaway. They had a soft haziness when printed, and Briggs wanted the pictures in his subsequent collection to be sharper. (One original from *Ring-a-Ring o' Roses*, of the butcher, the baker and the candlestick-maker at sea in a barrel, is labelled: 'Pictures for "The White Land" will be similar to this, but will have much more black.') So the full-page colour illustrations to *The White Land* (1963), a collection of traditional rhymes, were made with two juxtaposed images. The background was a gouache with free brushstrokes, and smudgy pastel, impressionistic in its melding of colours to represent skies and fields, walls and waves, people and animals, aprons

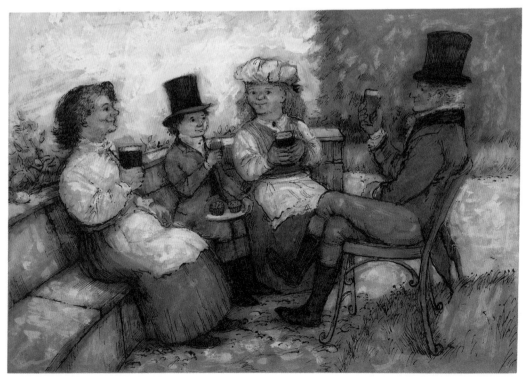

and mob caps. Overlaid onto each picture was an acetate sheet with scratchy ink drawing, defining outlines and adding minutiae. This was looser work than the earliest illustrations, allowing the frothy folds in a curtain or dress to be hinted at. The effect is richly textured, and full of light.

On the facing pages of *The White Land*, the rhymes were illustrated with ink drawings, using period dress from several centuries that hark back to the cross-hatching and the meticulous penmanship of earlier work. But this too is freer than before. The thickness of the ink line varies and there are moments of blotchy, scribbly, spattered drawing that invite viewers to resolve the image themselves – as in the heaped, bubbly fabric that overflows from a washing bowl. Briggs was starting to dare to move away from the precision he had mastered.

Although he breaks new ground, Briggs also belongs to an identifiable tradition. The influences on his early work

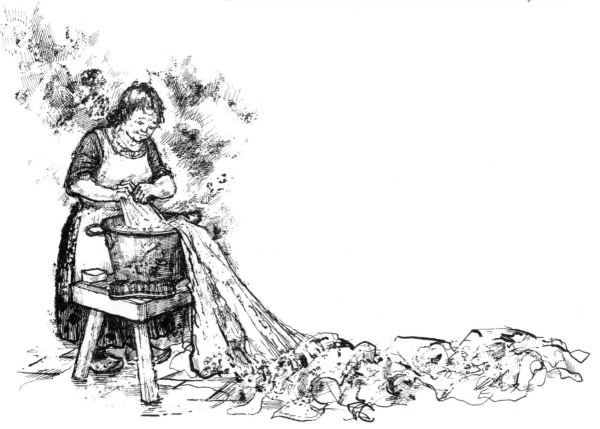

are many and various, but critic Philip Hensher, referring to Briggs's 'warm look', 'serious moral world' and 'attractively fuzzy style', saw him as 'peculiarly English', drawing 'on a line of beautifully domestic and idealistic English artists, going back through the great Edward Ardizzone to Samuel Palmer'.[13] Hensher could also have mentioned Stanley Spencer, the English painter who made the ordinary doughy-looking inhabitants of Cookham the subjects of epic Biblical scenes. Briggs has written of Spencer as his 'hero'. But the references to Ardizzone and Palmer are astute. Those squat figures appear in the work of both, and the rounded lines, and Briggs echoes Ardizzone's depth, creating a three-dimensional scene in a small vignette (often, in Briggs's case, in a square frame). Black-and-white landscapes appear in Briggs's illustrations for *The White Land* that recall Palmer's use of black line, patterned detail and romanticized settings. Palmer (1805–1881) drew (and etched) English landscapes with misty skies and churches.

BELOW
Robin the Bobbin,
The White Land, 1963

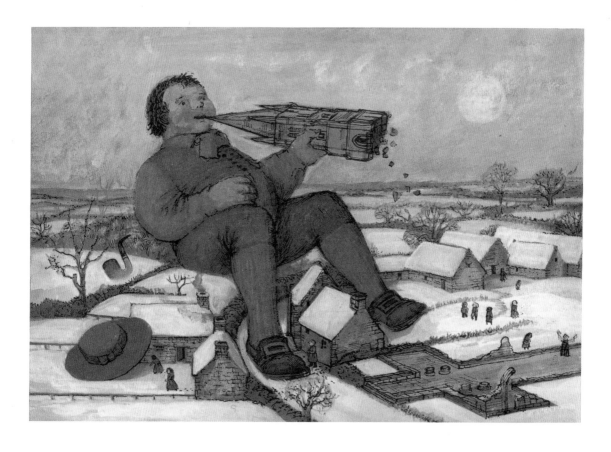

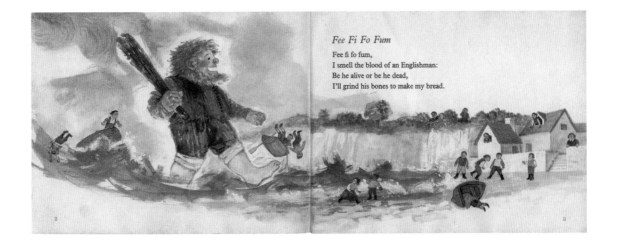

Fee Fi Fo Fum

Fee fi fo fum,
I smell the blood of an Englishman:
Be he alive or be he dead,
I'll grind his bones to make my bread.

In *The White Land* Briggs draws one in which a giant is eating the church.

By the time Briggs illustrated *Fee Fi Fo Fum* (1964), another book of nursery rhymes, he was varying his style within one book. A few of the pictures used an inked overlay for definition, but some of the illustrations were left as the irregular brushstrokes formed them. The hairy giant on the cover, for instance, has his rolled-up trousers and his cudgel imperfectly coloured in with scrabbly lines as he strides cheerily and destructively out of the sea. A lack of inhibition in the mark-making renders the images more childlike (and therefore the giant less terrifying).

Although by now little rounded folk are becoming the default Briggs characters, the inspirations are various for these pictures and the execution joyously inconsistent. Briggs's illustration of 'The Little Nut Tree' borrows the look of the King of Spain's daughter from Diego Velázquez's portrait of Mariana of Austria, with her hemispherical hair echoing the spread of her skirt, whose pattern, with its white braid on navy blue, Briggs has copied exactly. She stands against a painterly sky while the child in front of the nut tree, sunk to the ground in the presence of royalty, has her back to us. This device of representing overwhelming emotion by using a figure that is turned away from the viewer recurs in Briggs's work (he went on to use it later, for instance, in the last frame of *The Snowman*) – and it borrows from the traditional Renaissance representation

ABOVE

'The Little Nut Tree'. Artwork
for *Fee Fi Fo Fum*, 1964

OPPOSITE

Diego Velázquez, *Portrait of
Mariana of Austria,* 1652–53,
Museo del Prado, Madrid

24

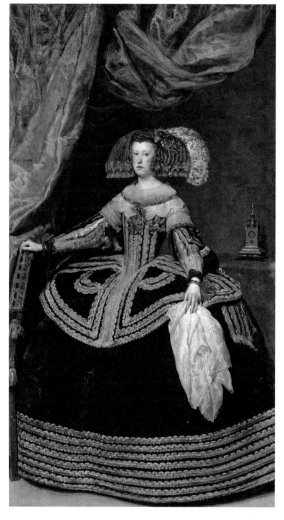

of grief, often a figure seen from behind at the foot of the Cross.

In the same book, the picture of a lady knitting, to illustrate the rhyme 'Golden Fishes', is evidently a portrait of Briggs's mother Ethel (the rhyme refers to 'mammy'). Briggs was having fun making use of any association – including playing cards and medieval illumination – and any material or method that worked. His illustrations also contain incident beyond the prescriptions of the text, as in all the best picture books. At the end of a row of medieval knights, for instance, is one who has eaten too much of the bag-pudding King Arthur made, with its 'great lumps of fat'; he looks green.

Briggs enjoys playing with scale; a violent little scene of people kicking each other about loses some of its fearfulness when we see in its companion black-and-white sketch that the kickers are tiny, watched by much bigger children, who look amused.

He also rises to the challenge of depicting animals, both as they actually are and as they are anthropomorphized in children's stories: so rats parade in silk, for example, and a self-satisfied pig lounges upright on a bench in a sty, while another gets a shave. Briggs has admitted that in *The White Land* he stole a horse being ridden into the sea on p. 39 from his much-garlanded fellow illustrator Victor Ambrus: 'I always pinch horses from him. He's the master of horse drawing.'[14]

BELOW
The woman knitting in this artwork for the 'Golden Fishes' nursery rhyme resembles Briggs's mother, Ethel. *Fee Fi Fo Fum*, 1964

BOTTOM
Briggs plays with scale in this spread from *Fee Fi Fo Fum*, 1964

OPPOSITE, ABOVE
Illustration of medieval setting for 'Good King Arthur', *Fee Fi Fo Fum*, 1964

OPPOSITE, BELOW
Briggs drew on the work of Victor Ambrus for this image. *The White Land*, 1963

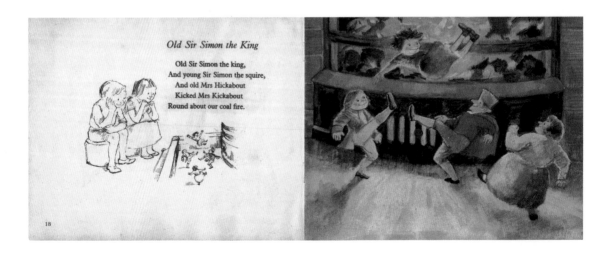

Old Sir Simon the King

Old Sir Simon the king,
And young Sir Simon the squire,
And old Mrs Hickabout
Kicked Mrs Kickabout
Round about our coal fire.

18

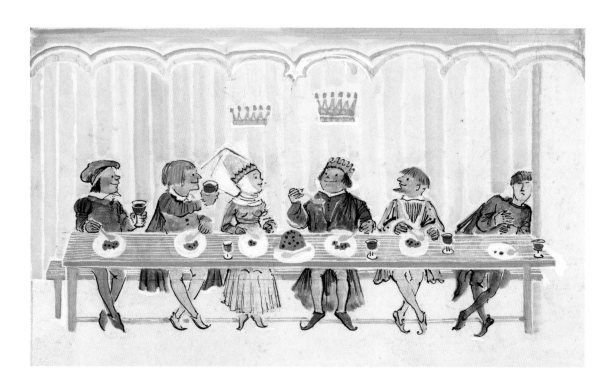

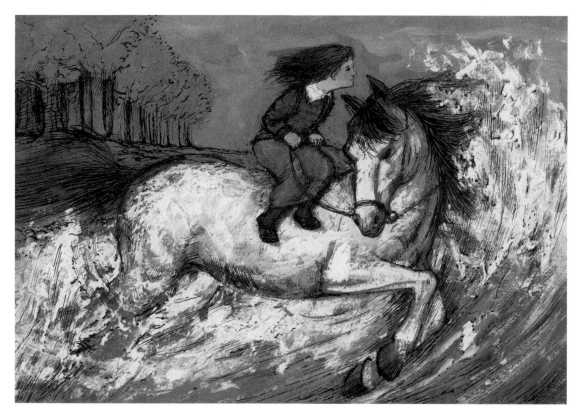

Fairies and giants

The first three collections of rhymes Briggs illustrated attracted an American editor, Alice Torrey, who suggested a co-edition of 'the biggest nursery rhyme book ever'.[15] It became *The Mother Goose Treasury* (1966), which went on to win Briggs's first Kate Greenaway Medal, the librarians' prestigious award for an illustrated children's book. It is extraordinary partly because it had no book designer, and every page is decorated as Briggs saw fit, pasting rhymes in the middle and doodling around them. He has called it 'very loose and rather messy'.[16] It is a hotchpotch of styles and media, getting conspicuously more frantic as it progresses through 224 pages, 408 rhymes and 897 images; by p. 211, illustrating the line 'My master he did cudgel me', the character is red-faced and blowing steam out of his ears. 'That's exactly how I felt',[17] Briggs has said. The pictures are little ink cartoons, and painted vignettes or larger scenes, variously suggesting a debt to Marc Chagall ('The Little

BELOW LEFT
'My master he did cudgel me', *The Mother Goose Treasury*, 1966

BELOW RIGHT
'If All the World', *The Mother Goose Treasury*, 1966

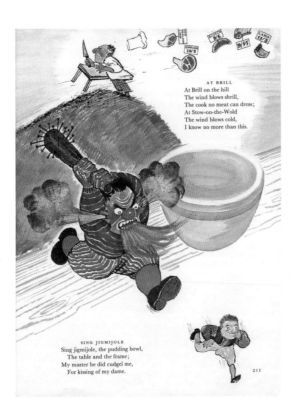

AT BRILL
At Brill on the hill
The wind blows shrill,
The cook no meat can dress;
At Stow-on-the-Wold
The wind blows cold,
I know no more than this.

SING JIGMIJOLE
Sing jigmijole, the pudding bowl,
The table and the frame;
My master he did cudgel me,
For kissing of my dame.

211

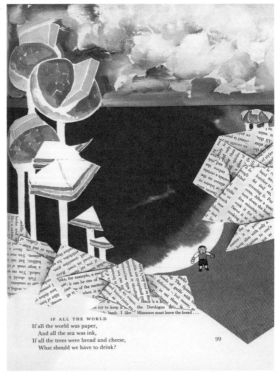

IF ALL THE WORLD
If all the world was paper,
And all the sea was ink,
If all the trees were bread and cheese,
What should we have to drink?

99

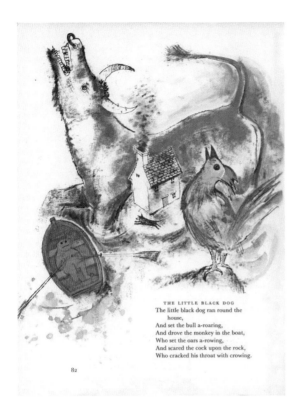

THE LITTLE BLACK DOG
The little black dog ran round the
house,
And set the bull a-roaring,
And drove the monkey in the boat,
Who set the oars a-rowing,
And scared the cock upon the rock,
Who cracked his throat with crowing.

82

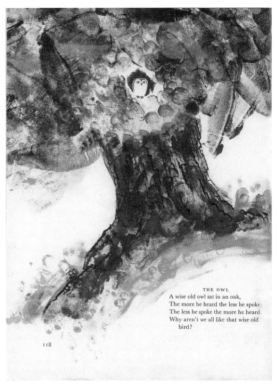

THE OWL
A wise old owl sat in an oak,
The more he heard the less he spoke:
The less he spoke the more he heard.
Why aren't we all like that wise old
bird?

118

ABOVE LEFT
'The Little Black Dog', *The Mother Goose Treasury*, 1966

ABOVE RIGHT
'The Owl', *The Mother Goose Treasury*, 1966

Black Dog'), using collage ('If All the World') and hand prints ('The Owl').

There are apparently two self-portraits in *The Mother Goose Treasury*, though they may also be representations of Briggs's father: one is a face on a rotten potato, another the face of the crooked man. Briggs's images in this book are often inventive, sometimes literal; wild in some cases and sweet in others – just as nursery rhymes are. They were perfect fodder for an artist of Briggs's boldness and originality.

The year 1968 saw the publication of both *The Christmas Book* (1968) and *The Hamish Hamilton Book of Giants* (1968). In both, the pictures are confident, accomplished, and beautifully composed. The first is a collection of sixty-one pieces of prose or poetry about Christmas edited by the poet James Reeves. It has seven full-page colour illustrations as well as atmospheric black-and-white images with a line that sometimes suggests rather than specifies the detail, and which matches the mood of each extract: exaggerated

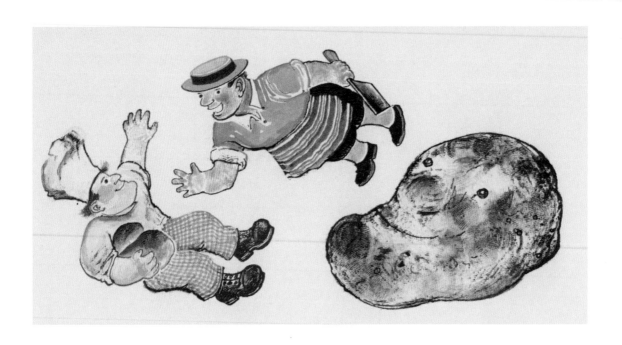

ABOVE
Rotten potato, *The Mother Goose Treasury*, 1966

LEFT
Crooked man, *The Mother Goose Treasury*, 1966

OPPOSITE
Artwork of a giant playing chess, *The Hamish Hamilton Book of Giants*, 1968

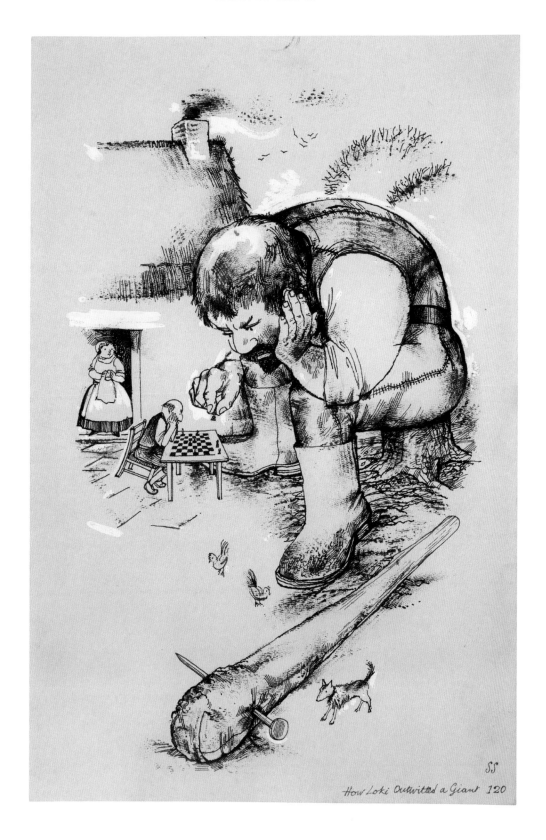

How Loki Outwitted a Giant 120

Please ensure. ½ Blood. all Round. Margie.

p.106 Cries of London — "Buy a nice tart!" "Hot loaf, hot cake!"

caricatures of street sellers for Alison Uttley; an explosion
of objects and characters including Struwwelpeter and
Alice in Wonderland to illustrate fecund Dylan Thomas;
light-hearted cartoons for Charles Dickens; mounted ghosts
portrayed in broken lines for Walter de la Mare's 'A Ballad of
Christmas'; and for Mary Howitt's memoir of a coal-mining
community, angular working men in an industrialized
landscape: Samuel Palmer meets German Expressionism.
Meanwhile, the colour scenes make rich use of light:
Pickwick on the ice is a scene of ravishing delicacy, with a
bright red waistcoat against the snow, and a wintry light.
Lanterns glow in the dark, a lit window is seen from outside,
street lights, lamps, firelight and shafts of cold white
daylight set the tone of each scene.

 The Christmas Book offers the surprising fact that Briggs
illustrated both *The Wind in the Willows* and Paddington
Bear. A scene from the chapter 'Dulce Domum' shows Mole
in his home, with Rat bringing logs, the simple interior

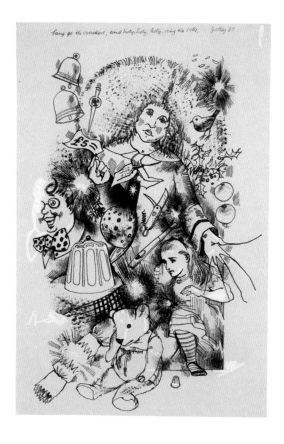

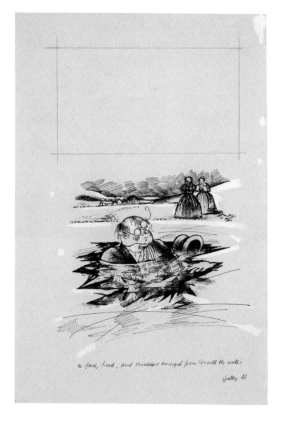

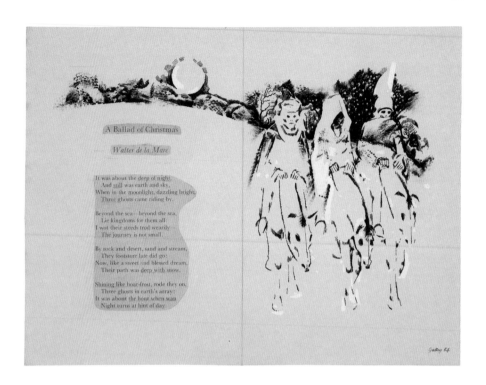

A Ballad of Christmas

Walter de la Mare

It was about the deep of night,
And still was earth and sky,
When in the moonlight, dazzling bright,
Three ghosts came riding by.

Beyond the sea — beyond the sea,
Lie kingdoms for them all:
I wot their steeds trod wearily —
The journey is not small.

By rock and desert, sand and stream,
They footsore late did go:
Now, like a sweet and blessed dream,
Their path was deep with snow.

Shining like hoar-frost, rode they on,
Three ghosts in earth's array:
It was about the hour when wan
Night turns at hint of day.

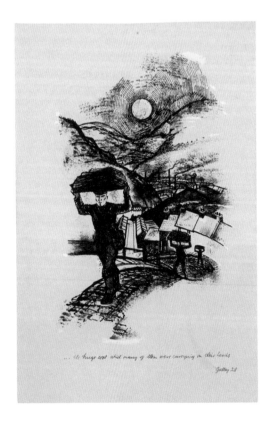

ABOVE
Artwork of ghosts for 'A Ballad of Christmas' by Walter de la Mare, *The Christmas Book*, 1968

LEFT
'The huge coal which many of them were carrying on their heads.' From Mary Howitt's memoir, *A Christmas Visit*, *The Christmas Book*, 1968

OPPOSITE
'Mr Pickwick on the ice.' Artwork for *The Pickwick Papers*, *The Christmas Book*, 1968

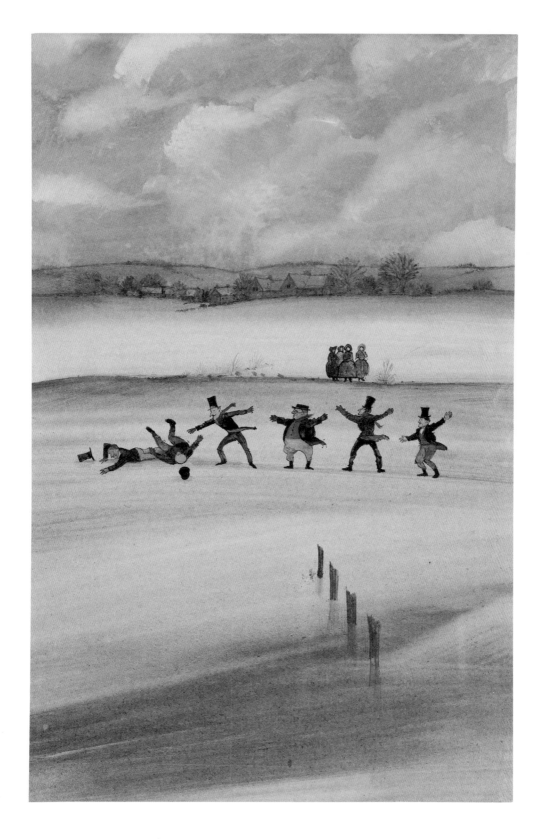

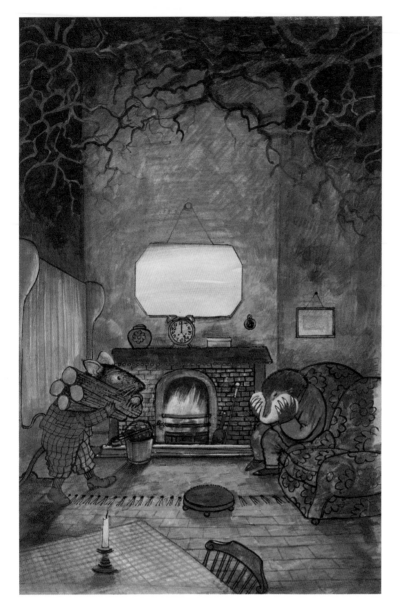

prefiguring Father Christmas's living room, or Ethel &
Ernest's. The Paddington drawings involve stippled smoke
and furry fur and Paddington with a flat cap and chemistry
set, and, in the cosy colour image, the bear snug in bed in
an oversized paper hat and a ray of light against soft
violet walls.

A sureness of line, adventurous use of perspective and
scale, a relish of unlovely faces, a wealth of imagination

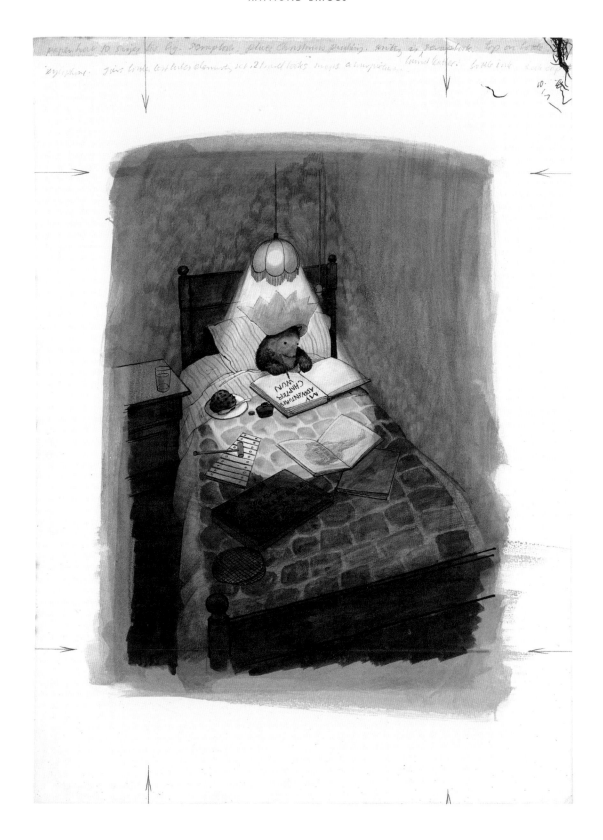

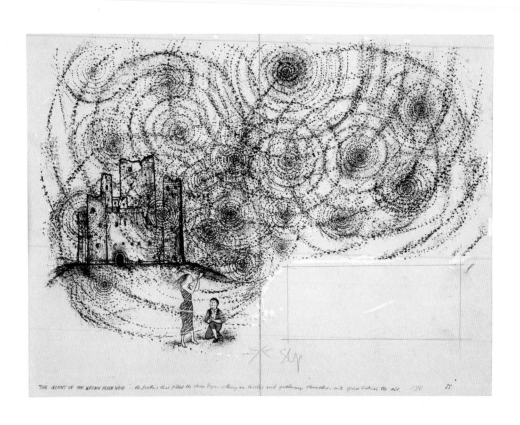

THE GIANT OF THE BROWN BEECH WOOD *...the feathers that filled the whole began whirling in circles and quickening clouds into spun betwixt the air...* 130 55.

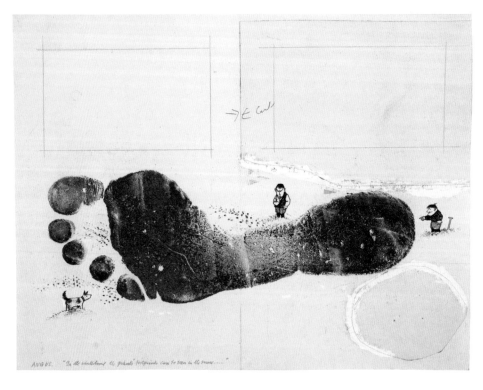

ANGUS. *"In the moonlight the giant's footprints can be seen in the snow......"*

OPPOSITE, ABOVE

'The feathers…gathering themselves into great circles in the air.' Artwork for 'The Giant of the Brown Beech Wood', *The Hamish Hamilton Book of Giants*, 1968

OPPOSITE, BELOW

'In the wintertime the giants' footprints can be seen in the snow.' Artwork using a print of Briggs's foot, *The Hamish Hamilton Book of Giants*, 1968

BELOW

Artwork for *Nuvolari and the Alfa Romeo*, 1968

and a capacity to anchor the fantastical in the everyday characterize *The Hamish Hamilton Book of Giants*, in which Briggs meets all challenges, drawing feathers flying in psychedelic circles of dots, for instance, and making use of his own footprint to represent a giant's.

Also in 1968, Briggs fulfilled a commission that ran counter to his own inclinations. Six illustrated 'Briggs books' came out about real-life adventurers, including two racing drivers, Tazio Nuvolari and Jimmy Murphy. Briggs was reluctant to draw cars and the exploits of the killing machine Manfred von Richthofen, the First World War fighter pilot known as the Red Baron, whose room was full of numbers cut from planes he shot down. What is of interest, though, is that Briggs depicted speed in a way that was indebted to Italian Futurists, using blurred lines.

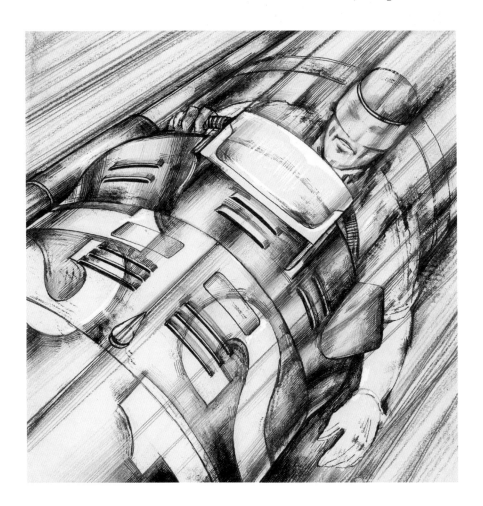

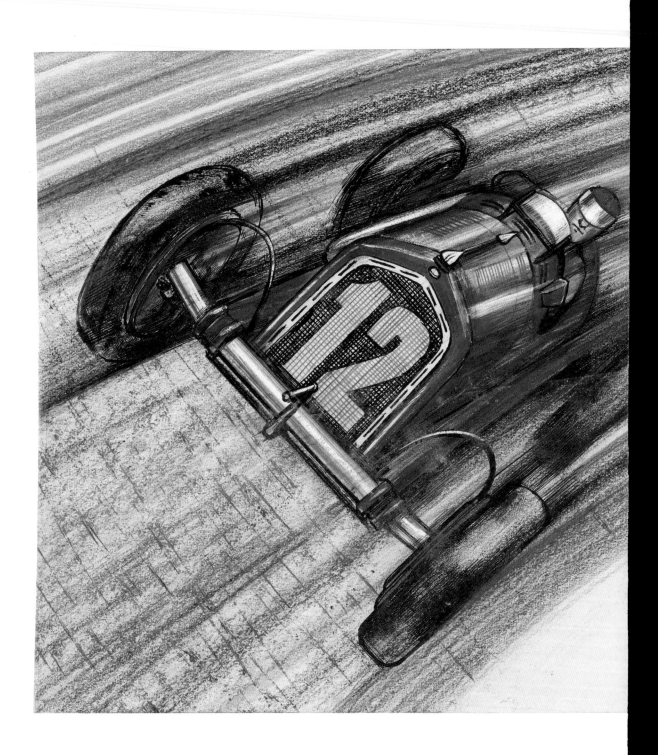

'Top speeds of 53 mph.' Artwork for
Nuvolari and the Alfa Romeo, 1968

Nuvolari shifted into third, and the Alfa Romeo's engine note rose to a scream. Shift into fourth. The car was a red blur against the dark green of the pine trees. Only, a few seconds behind was another of the Mercedes, and then Rosemeyer's Auto-Union, a hunch-backed monster of a car with a speed of 180 miles an hour.

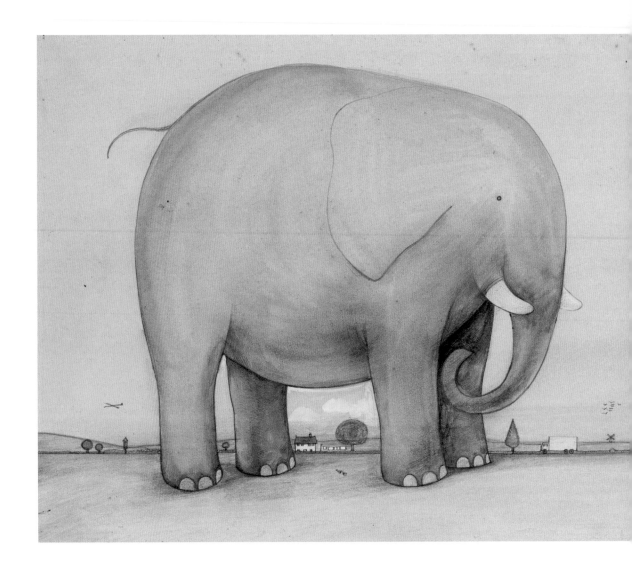

Artwork for *The Elephant and the Bad Baby*, 1969, showing Briggs's use of a low sightline

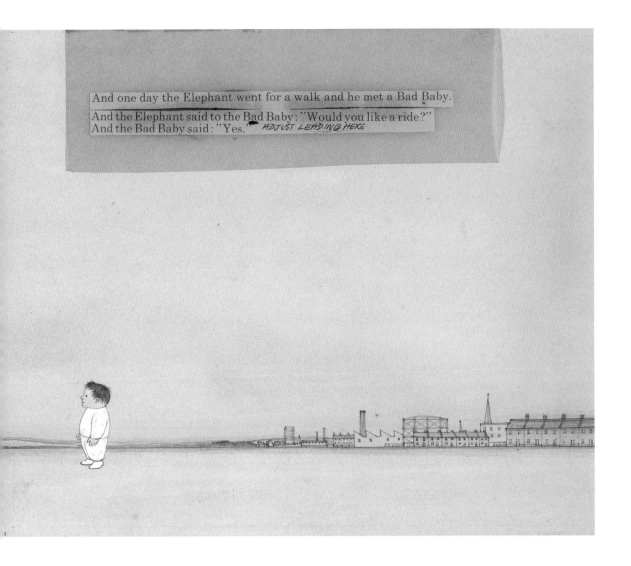

And one day the Elephant went for a walk and he met a Bad Baby.

And the Elephant said to the Bad Baby: "Would you like a ride?"
And the Bad Baby said: "Yes." *ADJUST LEADING HERE*

Briggs's illustrations to Elfrida Vipont's *The Elephant and the Bad Baby* (1969) produced a book of lasting popularity. It has delicious hues, a sweet shop, a cake display and an old-fashioned ice-cream cart. Among the features that made this book so successful was Briggs's use of a very low sightline, so that the elephant was seen as if by the baby, close to the ground, along with views from above – as observed by the baby on the elephant's back. There are also visual jokes in the pictures: hats that look like cakes or pies, for instance. And there are lively ink cartoons, by now a Briggs forte, of accumulating characters in pell-mell

Next they came to a sweet shop.
And the Elephant said to the Bad Baby: "Would you like a lollipop?"
And the Bad Baby said: "Yes."

 So the Elephant stretched out his trunk and took a lollipop for
himself and a lollipop for the Bad Baby, and they went rumpeta,
rumpeta, rumpeta, all down the road, with the ice-cream man, and
the pork butcher, and the baker, and the snack bar man, and the
grocer, and the lady from the sweet shop all running after.

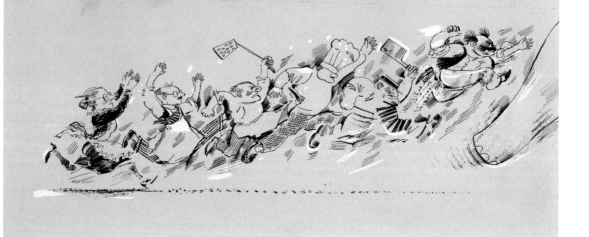

ABOVE

Artwork of shopkeepers giving
chase, *The Elephant and the Bad
Baby*, 1969

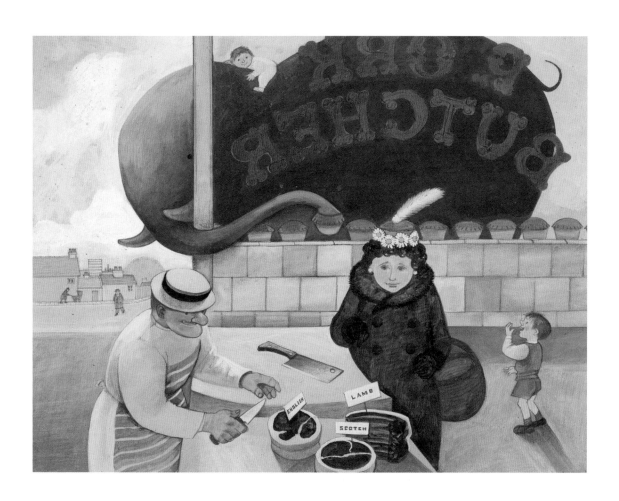

ABOVE

Butcher's shop. Artwork for *The Elephant and the Bad Baby*, 1969

ABOVE

Artwork for *The Elephant and the
Bad Baby*, 1969, showing Briggs's
instructions about the colours

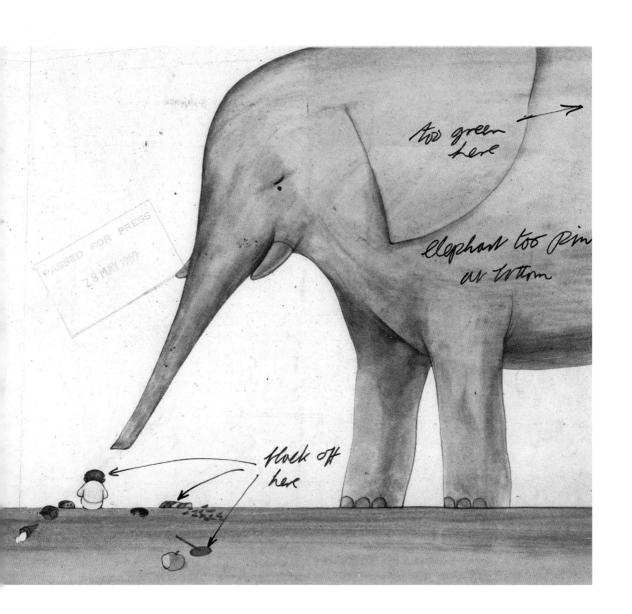

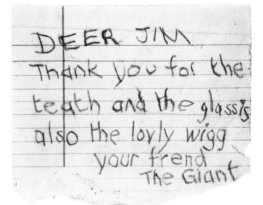





DEAR BOY
Time to moov on
THANKS FOR putting up with me
SoRY I stayed to Long
3 DAYS is ouR RooL
You wer moR kind to me
than ANNY won els in the hole
of my life.

YOU AR A GooD BLoKE
Yor old MATE
man

P.S. She brought my cloathes

DEER JIM
Thank you for the
teeth and the glassis
also the lovly wigg
your frend
The Giant

pursuit, to complement the multi-coloured images. (Briggs
originally made the elephant more colourful still: his notes
on the artwork tone down the elephant's pink bottom and
green ear.)

Briggs had had a lot of practice with drawing giants (who
tend to resemble him) by the time he wrote and illustrated
Jim and the Beanstalk (1970), in which Jim makes amends
to an elderly giant, whose treasures were stolen by Jack.
Jim sorts out enormous specs, false teeth and a wig. The
giant, stubbly and grumpy, is demanding and troublesome to
the sensitive boy who helps him. This character foreshadows
the Man. Both leave not very literate thank-you notes:
one from 'Your frend The Giant', the other from 'Yor old
mate Man'. Caricature (people fall over in surprise) meets

WHOLE PICTURE
MORE LOWER

The dentist could hardly believe his eyes when he saw the giant gold coin, but he set to work straight away. He worked all night, and in the morning the teeth were ready. Jim carried them home. Then he tied them on his back and climbed up the beanstalk.

The Giant loved his glasses and began reading rhymes to Jim as soon as he put them on.

"You're a good boy," he said. "Now I can see you properly I wonder what you'd be like to eat? I can't eat anything much nowadays because I've got no teeth."

"Why don't you have false teeth?" asked Jim.

"False teeth!" roared the Giant. "Never heard of them!"

So Jim explained about false teeth while the Giant listened carefully.

"Get 'em!" said the Giant when Jim had finished. "Get 'em for me. I'll pay good gold."

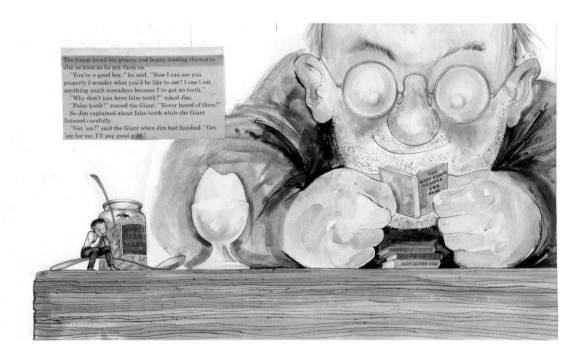

Surrealism (false teeth with legs) and realism (a wasp in the marmalade). Big watercolour brushstrokes shape the bulk of the giant; fine ink lines define the much smaller boy.

The Fairy Tale Treasury (1972) marked the beginning of Briggs's fruitful collaboration with his editor Julia MacRae at Hamish Hamilton, who became the midwife to Briggs's most celebrated creations. The fairy tales demonstrate Briggs's talent for clarity: every drawing 'reads' lucidly and precisely. He also matches the medium to the message, notably in the illustrations to *Goldilocks*, who is fiercely rendered, with hair like metal springs and an angry scowl.

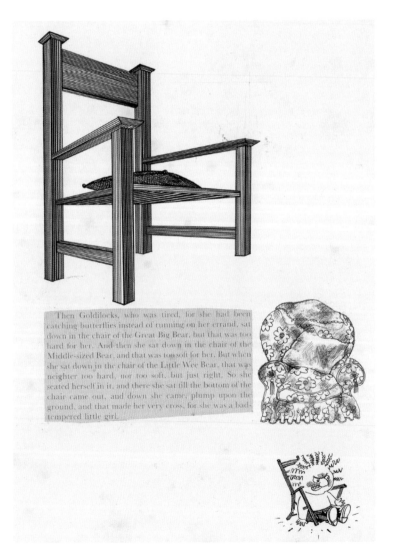

Then Goldilocks, who was tired, for she had been catching butterflies instead of running on her errand, sat down in the chair of the Great Big Bear, but that was too hard for her. And then she sat down in the chair of the Middle-sized Bear, and that was too soft for her. But when she sat down in the chair of the Little Wee Bear, that was neither too hard, nor too soft, but just right. So she seated herself in it, and there she sat till the bottom of the chair came out, and down she came, plump upon the ground, and that made her very cross, for she was a bad-tempered little girl.

LEFT
Too hard, too soft, and quite fierce. Bears' chairs, and Goldilocks. Artwork for *The Fairy Tale Treasury*, 1972

OPPOSITE, ABOVE
Two distinct styles: the emperor and the laughing crowd, *The Emperor's New Clothes*, *The Fairy Tale Treasury*, 1972

OPPOSITE, BELOW
Imitation of a Japanese print, *The Fairy Tale Treasury*, 1972

Great Big Bear's hard Charles Rennie Mackintosh-esque chair and Spartan bed are drawn with straight black lines and sharp angles; and Middle-sized Bear's flowery too-soft armchair is all cross-hatched to evoke squishiness. Similarly, the naked emperor in *The Emperor's New Clothes* is conjured with a rococo line, borrowed from Aubrey Beardsley, because it suggests the fancy style he thinks he is wearing. But the crowd that laughs at him is drawn as if in a newspaper cartoon – the role of the spectators is broad and comic. A Japanese fairy tale is illustrated with a certain disregard for distinction between the Chinese and the Japanese, with images indebted to Japanese Ukiyo-e prints, a Chinese dragon and willow-pattern plates.

Whereas *Ring-a-Ring o' Roses* made nursery rhymes pretty, Briggs peoples this collection with the snub-nosed, the big-chinned, the balding, the unshaven, the buck-toothed. There are things of beauty in it, such as shiny two-tone brogues made by elves, but honest Briggsian grunge is surfacing.

Father Christmas and *Fungus*

We tend to think of cartoon strips with simplified, rounded figures and carefully observed everyday settings as typical of Briggs, but on close inspection, this underrates his breadth. His books reveal a mastery of an impressive variety of materials and techniques – in ink, pastel, pencil, watercolour, crayon, pencil crayon, chalk, gouache, collage, etching and the smudged line produced by old photocopiers. He has even incorporated correction fluid into his pictures and his earliest published work was on scraperboard, showing skilled and precise draughtsmanship: it was an illustration to a guide to how deep to plant your bulbs.

For his entire career Briggs has been a one-man band, responsible for all aspects of his books – which is time-consuming, as he has observed:

> *You can easily spend more than two weeks on a single page. Writing, drawing and design are all going on at the same time. In most publishers there is more than one person at work: writer, designer, illustrator and colourist. But there are some who do the whole jolly lot themselves, can you believe?[18]*

Briggs's next great success, *Father Christmas* (1973), brought to fruition techniques that had been germinating in his work to date: notably the observation of the domestic detail of ordinary lives, and frame-by-frame storytelling. Wishing, he says, to fit more on a page than conventional picture books allowed, he resorted to the comic strip, unleashing his inner miniaturist. (The form requires, for translation, empty speech bubbles in the artwork, with the text on an acetate overlay.)

Hitherto, cartoon strips were not a feature of British children's book illustrations. Briggs helped to elevate the status of the comic strip and the graphic novel in Britain, which at the time did not generally show the respect for the form that existed in, say, France, where *bandes dessinées* are valued as a literary and artistic form. A similar attitude may account for Briggs's huge popularity in Japan, where manga is an established cartoon tradition, received without

OPPOSITE

The elves' two-tone brogues, *The Fairy Tale Treasury*, 1972

OVERLEAF

Father Christmas's morning routine. Artwork spread for *Father Christmas*, 1973

53

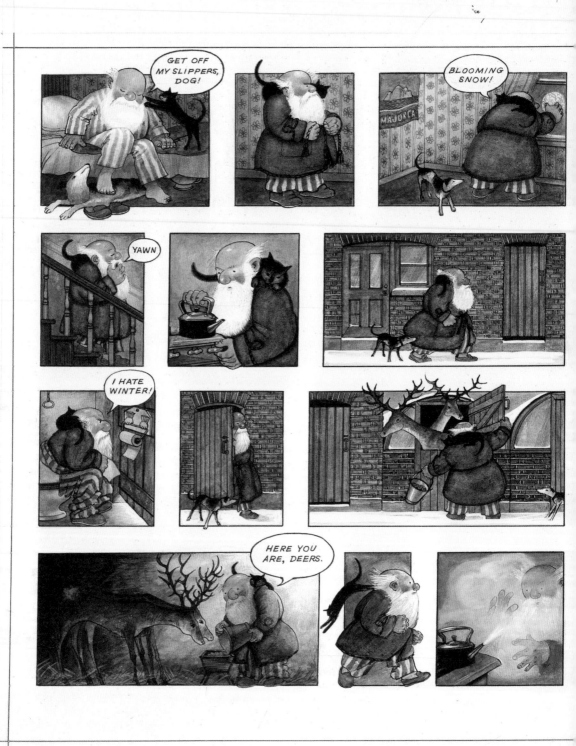

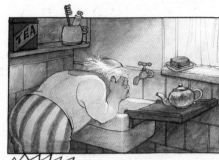

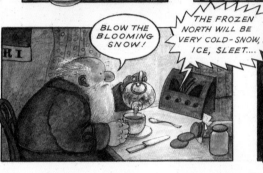

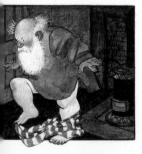

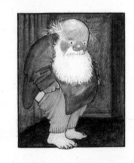

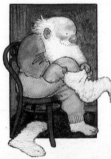

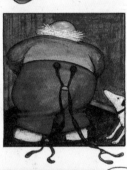

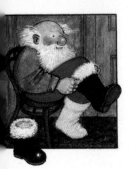

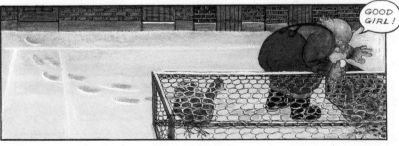

7

snobbery. (When Briggs was included in the 'World of English Picture Books' exhibition that toured Japan 1998–99, audiences queued round the block to see him.)

His Father Christmas broke a mould. Santa had, until now, been saintly, regal, powerful: a factory owner managing a production staff of elves. Briggs responded to the 'Father' part of Father Christmas, and based the character on his. After all, Ernest and Santa Claus had in common the obligation to work a delivery round in all weathers. This made Briggs's the first working-class Father Christmas, and everything follows from this: his morning routine, his way of expressing himself (the idiosyncratic 'blooming'), his kitchen, his outside loo, his opinions, possessions and habits. The connection between Briggs's father and his Father Christmas is acknowledged in one frame: Ernest Briggs, whose milk float's number plate has his initials and year of birth (ERB 1900), encounters Santa. 'Still at it, mate?' asks Ernest. 'Nearly done' is the reply. Also personal is the inclusion of Briggs's houses on Father Christmas's round. Alongside an igloo, a caravan, the Houses of Parliament

BELOW
Father Christmas on his round, meeting Ernest Briggs. Artwork for *Father Christmas*, 1973

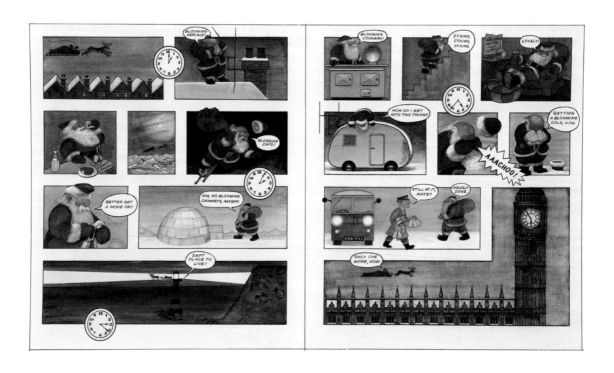

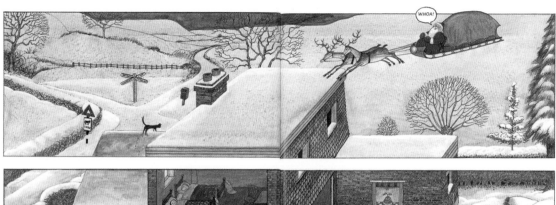

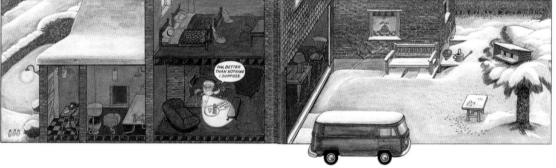

and Buckingham Palace the sleigh lands on the roof of
Briggs's Sussex home (as a signpost confirms) and visits
his parents' terrace in Wimbledon Park. In a double-page
spread of Buckingham Palace, the sleigh's last call, Briggs's
experience of detailed architectural drawing in his books
of houses, churches and castles shows. But he uses a new
technique with the snow on the palace forecourt: it is
made of granular watercolour, so the surface of the picture
is rough.

The book is both funny and sad, realistic and escapist.
The sleigh round is a tiring slog, but there are comic touches.
Briggs worked while his wife was in hospital with leukaemia,
and was presumably transported into another time and
place by this project. And as he showed her the work in
progress, perhaps he hoped to amuse and distract her too.

Jean died in 1973.

Her death followed closely the death of Briggs's parents.
Ethel died in 1971 at 76, as Raymond recorded in *Ethel &
Ernest* – an experience so painful that twenty-five years later
he could only work on the relevant images for ten or fifteen
minutes at a time. Ernest, who struggled to cope without

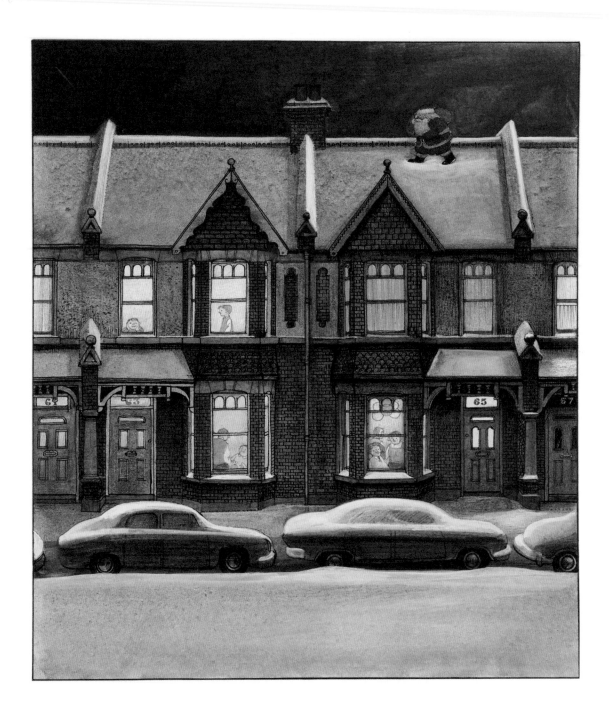

ABOVE

Briggs's parents' house, Wimbledon
Park, in artwork for *Father
Christmas*, 1973

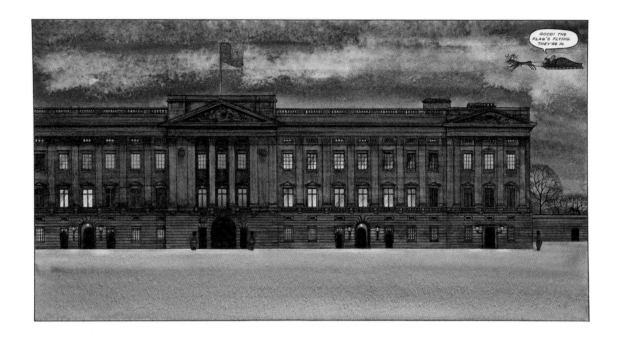

Artwork of Buckingham Palace,
Father Christmas, 1973

his wife, was diagnosed with stomach cancer and died nine months later. The grief of these few years of Briggs's life was profound and lasting.

Yet the book he worked on throughout this sad time is a great achievement. Briggs's process is meticulous. It is partly because his work belongs to a pre-digital era, with no 'click-and-fill' and no 'cut-and-paste'. Everything is hand-made, despite repetitiveness. Even on a tiny scale Briggs conjures textures: the fur on Father Christmas's cuffs echoes his fluffy beard; bricks and hung tiles are ubiquitous in this book, not only individually drawn but shaded in graded colour, pink to purple, as in reality, or elsewhere the matt yellow of newer bricks; skilled watercolour creates skies of louring rain clouds, lightening at dawn to a lilac blue.

So much is communicated in the pictures, such as how Father Christmas feeds his reindeer, his cat (who likes to sleep on his head and sit across his shoulders), and his dog, a Jack Russell, and how he wears long johns under his trousers, and collects eggs from his brown hens. We see his old-fashioned cooker and copper water-heater, his chamber pot, mechanical alarm clock, non-electric kettle, and two radios, the Art Deco wireless and the more modern

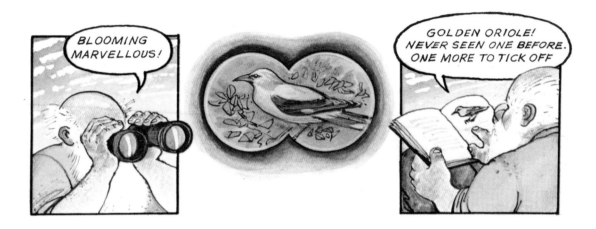

transistor (see pp. 54–55). The pictures have depth and an abundance of information. Each tells a story in itself, and the plethora of artwork multiplies the effort most picture books require. He builds the narrative as painstakingly as he draws walls, frame by frame, like a bricklayer. No wonder this book has endured. And no wonder the publisher wanted a sequel.

We saw Father Christmas dreaming of the sun in the first book. So in the sequel (1975) he goes on holiday. Briggs was offered three trips after Jean died. Where he went is where his character goes, though not by the same means: Santa converts his sleigh into a caravan. His travels yield the sight of a golden oriole in France but also an upset tum; whisky, haggis and dancing in Scotland but cold weather; and luxury in Las Vegas, but big bills. For the viewer, the holiday yields a feast. Briggs gives us the faces of gamblers, the synchronized pattern of a high-kicking chorus line at Nero's Palace, twilight over Vegas, the daisy-spotted lawn of an overgrown garden after an absence, and all the rich narrative detail we have come to expect.

ABOVE
Father Christmas sees a golden oriole in France. *Father Christmas Goes on Holiday*, 1975

OPPOSITE
Chorus line, Las Vegas, *Father Christmas Goes on Holiday*, 1975

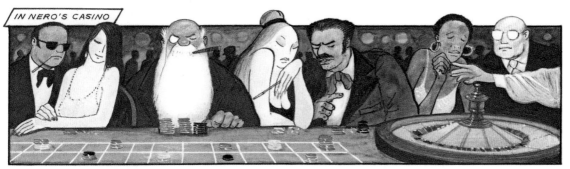

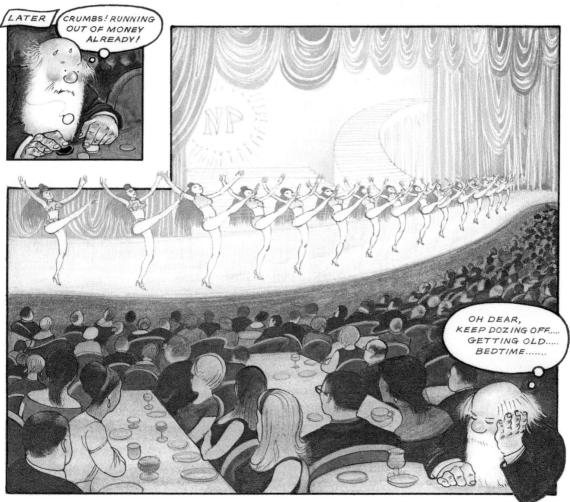

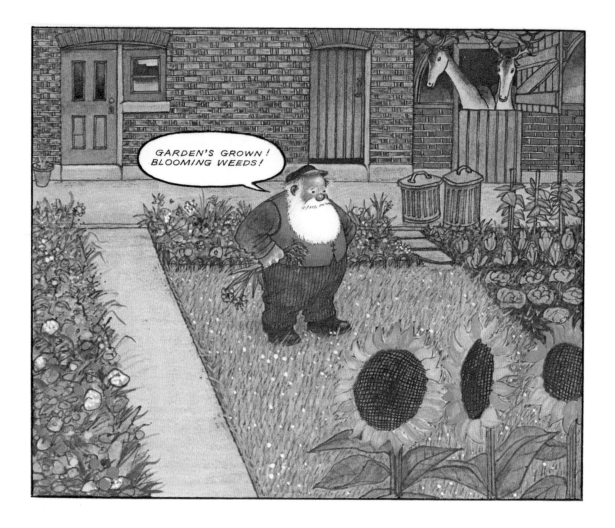

Around 1975 Briggs met Liz, a divorced mother of two, who was to be his partner for forty years. Over that time her two children and three grandchildren became his family, although he and Liz never married, and they kept their two separate houses: Raymond's with his studio with its north light and view over the Sussex Downs in Westmeston and Liz's darker cottage in nearby Plumpton.

Briggs's home is, perhaps unsurprisingly, distinctive. Paintings of his parents adorn cupboard doors in the living room and the ceiling is papered with maps of the British Isles. His habit of collecting the unexpected (usually triggered by a coincidence, or a joke) is manifest in, for instance, a tower made of the plastic lids of coffee cups in the bathroom (an allusion to T. S. Eliot's *The Love Song of*

ABOVE
Returning to an overgrown garden. *Father Christmas Goes on Holiday*, 1975

OPPOSITE
Portraits of his parents, Ethel and Ernest, on cupboard doors in Raymond Briggs's home at Westmeston

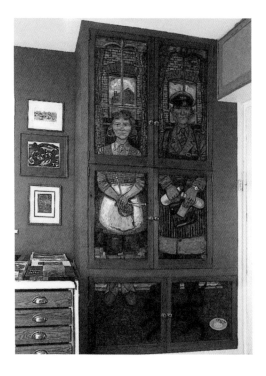

J. Alfred Prufrock – 'I have measured out my life with coffee spoons'), bathetic posters of headlines from the local paper ('Five pairs of shoes to be won') and a series of completed jigsaws of the Queen Mother.

Briggs's acquired family would influence his work. It was a remark by Liz's son that inspired *Gentleman Jim*, and something said by one of the grandchildren (to whom the book is dedicated) that gave rise to *The Puddleman*: ('They haven't put any puddle in that one'). Contrary to Briggs's reputation for not being fond of children, he always speaks of these youngsters with warmth. Contemplating a photograph of Liz's three grandchildren, he once said: 'That one liked to climb on my head. It was lovely.'[19]

Father Christmas was the book that made Briggs famous, but although it was immediately popular, not everyone loved it. Briggs received a letter of complaint from an American Baptist about his picture of Father Christmas on the lavatory. Julia MacRae's note on an original pleaded for no full-frontal nudity. And Briggs's next book was a challenge to the squeamish. The deliberate grossness of *Fungus the Bogeyman* (1977) was unprecedented in

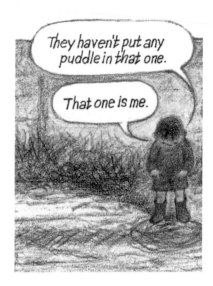

children's books – though snot and farts have become a staple since.

Surprisingly, Briggs has said that Fungus resembles his mother. She was not green and did not have hairy ears and a Mohican, but she does indeed share Fungus's wide mouth and nose. And a close reading of the book reveals that the character is indebted to Ethel. He is gentle and truthful and he loves his family: his wife, Mildew, and his son, Mould, are his consolations. Bogeymen are quiet, shy and polite. Fungus is a pacifist. Bogey guns are made of wood, and do not fire.

Fungus is of course also Ethel's antithesis: she was both fastidious and unintellectual. To Fungus cleanliness is revolting, but words and ideas are his passion, and he quotes poetry.

Fungus the Bogeyman is, for a picture book, astonishingly wordy, and, rather plotlessly, concerns Fungus's inner life and daily routine. Briggs had 'half a filing cabinet' of vocabulary he might use in the book: reading a dictionary from 1918 he found such happy coincidences as 'barathrum', a pit of muck, for a Bogey bathroom, and 'tyre', curdled milk, so this is what Bogey bicycle wheels are filled with. It is a work full of wordplay, with for instance a wall of books with Bogey substituted for a word in the title – and a portrait of 'Bogey' (Humphrey Bogart).

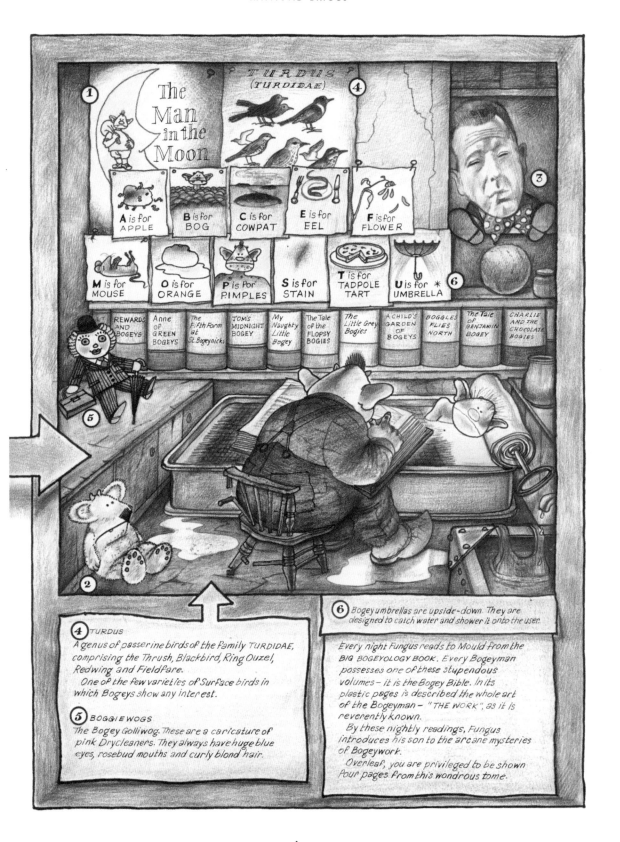

Briggs is attuned to the playground fascination with bodily functions, but he is not simply sniggering childishly. He is asserting our unfiltered humanity. We live in a world where things rot, as we will, and where there are boils and dirt and damp and mould. These things are not so disgusting as our inhumanity to each other. And yet we pretend they are no part of us. This hymn to *nostalgie de la boue* is where Briggs's bubbling fascination with the stuff his mother would not have wanted him to mention has boiled over. It is a rejection of pretension and propriety.

As this book proves, Briggs has a taste for the scatological and indecorous. Therein lies one of his qualities: an unflinching determination to depict the truth. There is beauty and decorative loveliness in his art, but he will not prettify: he rejects the pretence of prissiness or soppiness. He will have nothing to do with fakery. It is better to be explicit than to be dishonest. And the truth, as Briggs sees it, includes the earthy and the repulsive.

Julia MacRae came to regret an act of censorship with this book. Originally, Bogeys still had their umbilical cords. MacRae decided that was too much, and caused the image to be blacked out, though the text still told us what was there. But of course it fitted with the theme of family ties, the preoccupation with our beginnings and our ends, and also expressed something Briggs felt. It was a metaphor for his attachment to his own mother.

In fact, although the text tells us about slime and gunge, the images are not in themselves revolting; they depict unpleasant situations, but without the words there would be nothing to haunt our nightmares. Briggs does a great job of suggesting slime: the endpapers for example are made with gouache and his own handprints, as if with a Bogey's webbed fingers. Still, the pictures alone show marital affection, industriousness and studiousness, and nothing worse than cowpats and boils.

It is hard now to recognize how original and inventive *Fungus the Bogeyman* was. Like all great literary and artistic creations, it has become so much a part of our frame of reference that we forget the world in which it did not exist. The green creature, with the dorsal fin and the webbed hands, is an innovation, not only giving us an idea

OPPOSITE
Page showing a Bogey with a blacked-out umbilical cord, after the publisher considered the image too explicit, *Fungus the Bogeyman*, 1977

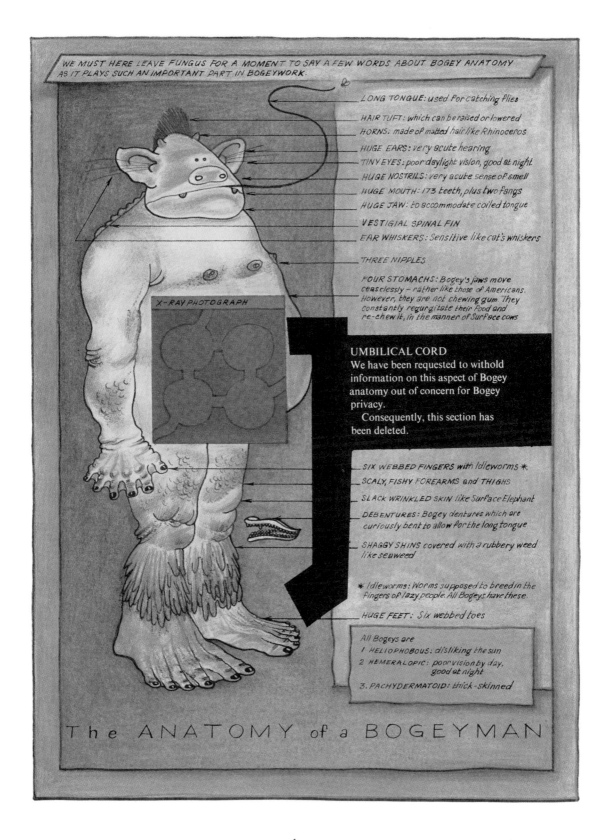

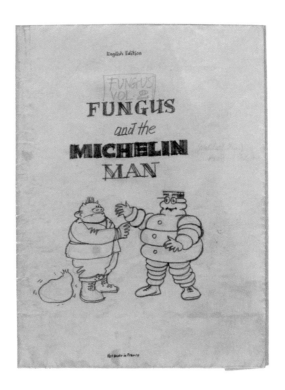

of what a Bogeyman might look like, but expanding the boundaries of possibility for illustrated books, and bringing us all closer to recognizing the truth about the festering, pustular physicality of the human condition. 'Everyone's got that in their life.' Briggs has said. 'Everyone has to deal with disgusting things, being sick, going to the lavatory, having diarrhoea...'[20] Fungus's biggest fans were students, who embraced the alienated, disaffected character along with the vocalist Sid Vicious, as a hero of punk.

Four sequels were planned, and there are preparatory drawings for *Fungus and the Michelin Man*, in which Fungus tries unsuccessfully to set up a tourist industry for Bogeydom. *Fungus and the Bumper Book of Bogey Verse* and *Fungus and the Triumphs of Bogey Technology* were to follow. And Briggs toyed with a book in which Fungus meets Father Christmas, who refuses to extend his round to Bogeydom: 'Not blooming likely!' So Fungus takes on the job, trying to teach two beeves, Slush and Turbid, to fly. Again, there are drawings. But something else came up.

ABOVE

Draft cover for *Fungus and the Michelin Man*, an unpublished sequel to *Fungus the Bogeyman*

Dreams and nightmares

After two years of baroque verbosity and slime, Briggs
needed to make something simple, silent and clean, like
snow. And one morning he woke to a different quality of
light in his room...His wordless *The Snowman* (1978)
meant a change of medium: after the sticky-looking gouache
of *Fungus*, he used the softness and luminosity of pencil
crayon, and adopted a palate of white and grey, with
pinkish, orangey shades of red. He drew from his
imagination, except in one sequence: the series of frames
of the sleeping, nameless boy was based on drawings
of Liz's son, Tom.

 The book, about the snowman who befriends the boy who
built him, immediately had a wide reach because wordless
picture books speak to all ages and languages. The story
follows logically from the premise of a snowman come to life:

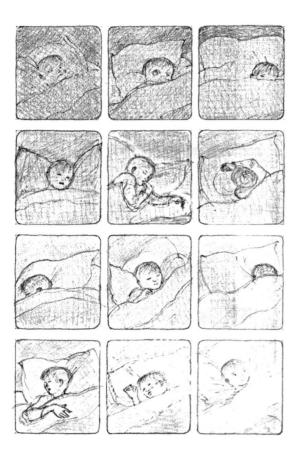

LEFT AND OPPOSITE
Drawings of a sleeping boy, for
which Liz's son, Tom, was the
model, and the finished sequence,
The Snowman, 1978

OVERLEAF
The snowman reacts to heat.
Spread from *The Snowman*, 1978

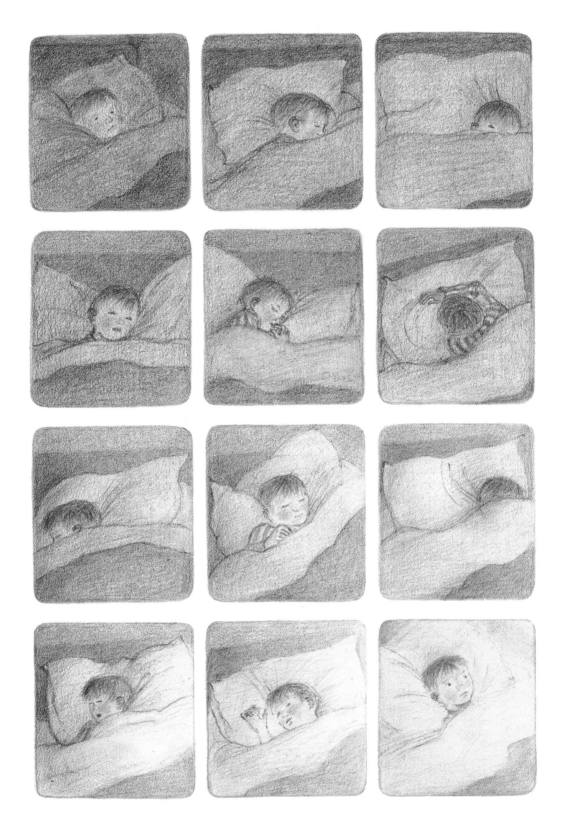

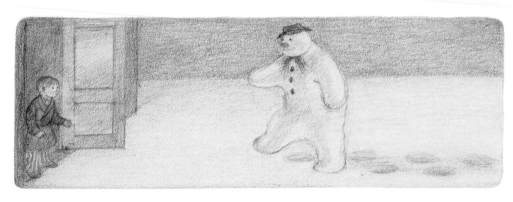

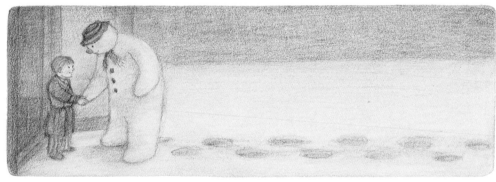

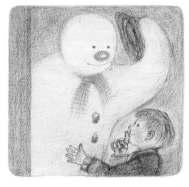

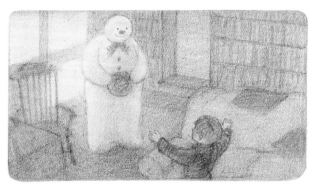

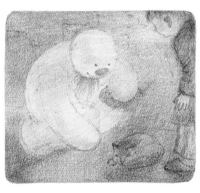

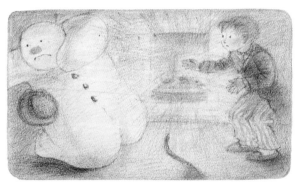

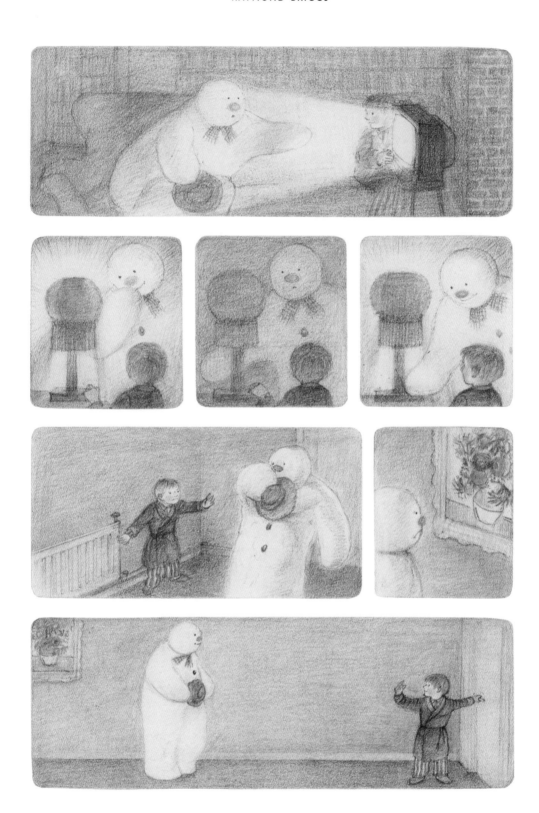

he dislikes fire, steam and Van Gogh's *Sunflowers*, which suggest heat. 'It made sense for a snowman to fly, because snow flies down from the air,'[21] says Briggs. And as a snowman melts, it leaves us with the message: things pass.

Posy Simmonds has written about this 'timeless, brilliant' book:

> *Over the years, Raymond Briggs's pencil has drawn everything about being human – the comic, the tragic; passion, tenderness, fear, anger, joy, bogeys… slime. In* The Snowman, *his soft crayons give the story a magical, dream-like effect. Sometimes the pencil lines propel, as in the scenes of flying. Sometimes they stroke, as in the panels of the sleeping boy and the final, poignant image of the melted snowman.*[22]

Everything about the snowman himself suggests softness, from the rounded lines of his body and limbs, to the open weave of his short scarf.

Briggs's book is wintry, but not Christmassy. The visit to Father Christmas was added to prolong the animated film version, and Briggs's snowman never gets any nearer to the North Pole than Brighton Pavilion. In fact, says Briggs, 'it hardly ever snows in Sussex before Christmas'.[23]

The book won four international awards, and the television animated film made in 1982 by John Coates, which had such an impact on the public consciousness, won a BAFTA. Howard Blake's song 'Walking in the Air' made the career of Aled Jones (although Peter Auty sang on the soundtrack). There were spin-off books, a text based on the story recorded by Bernard Cribbins, a Sadler's Wells ballet and unquantifiable merchandise.

By 2017, the running total of sales of *The Snowman* stood at 8.5 million copies and the film had become a Channel 4 Christmas staple for decades. Briggs is not in the habit of settling down to watch; he likes to play up his aversion, not only to the movie, and the music, but to the Christmas season in general. For the fortieth anniversary in 2018 other illustrators paid tribute with their own versions of *The Snowman*, and the pictures, along with Briggs's original

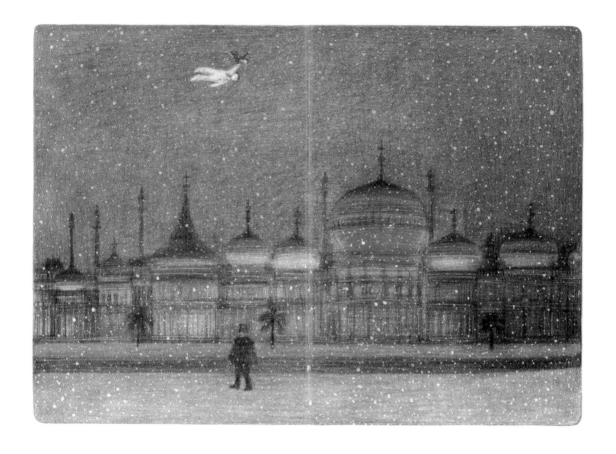

drawings, were exhibited in Brighton and raised £10,000 for a Sussex children's hospice, a charity chosen by Briggs.

Images from *The Snowman* appeared in 2003 on the Isle of Man's 50 pence coin (including the first ever colour image on a coin), in 2004 on Royal Mail stamps and in 2005 a limited-edition set was issued for Childline's twentieth anniversary.

Dreams of a different kind feature in Briggs's next book, *Gentleman Jim* (1980). These are the aspirations of a lavatory cleaner in Birmingham, an innocent whose grasp of the way the world works is so limited that he gets into trouble when he tries to make his life more exciting. The book is a link in the chain from Fungus to Ethel & Ernest: like Fungus, Jim Bloggs has a rich interior life and a mundane job; like Ethel & Ernest he is short of qualifications. He is puzzled by the 'Levels' young people leave school with. 'All we got was a Bible and a thick ear.'

ABOVE
Brighton Pavilion,
The Snowman, 1978

Gentleman Jim

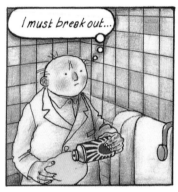
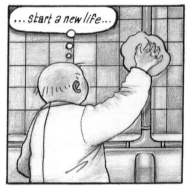
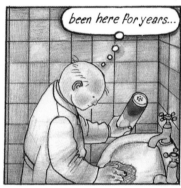

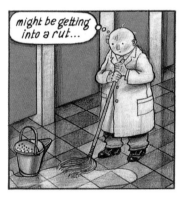
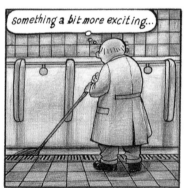
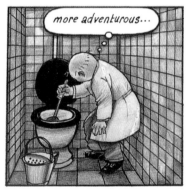

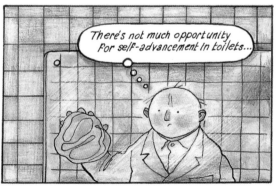

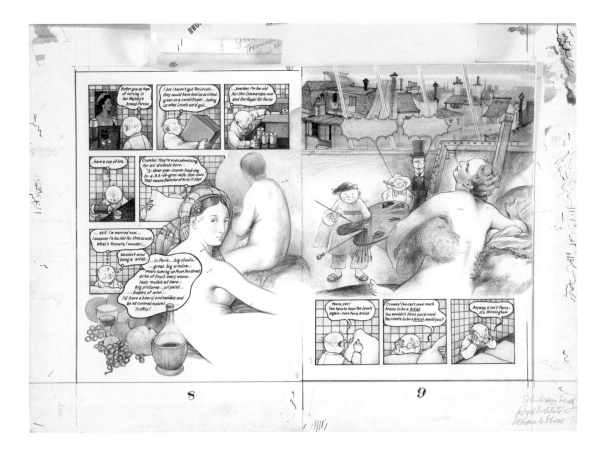

Jim's life cleaning lavatories is seen to be almost colourless, and the lines of bathroom tiles surround him like a cage. His fantasies, by contrast, are intensely coloured and burst out of the little boxes that circumscribe his life. Jim draws on his memories of the war and *Boy's Own* fiction, when he imagines a 'triffic' life as a pilot in the air force. But Briggs uses allusions that are likely to be outside Jim's frame of reference to draw his daydream of being an artist: Jean-Auguste-Dominique Ingres' *Odalisque* and Correggio's painting of Jupiter in the form of a cloud seducing Io. And Briggs uses this episode to make fun of himself: 'You can't need much brains to be a Artist. You wouldn't think you'd need The Levels to be a Artist, would you?'

Practicalities thwart Jim's laughable attempts to be a cowboy or a highwayman. This satire of red tape, and also of the misleading glamour of advertising and sentimental fiction, parodies the language of authority figures. The

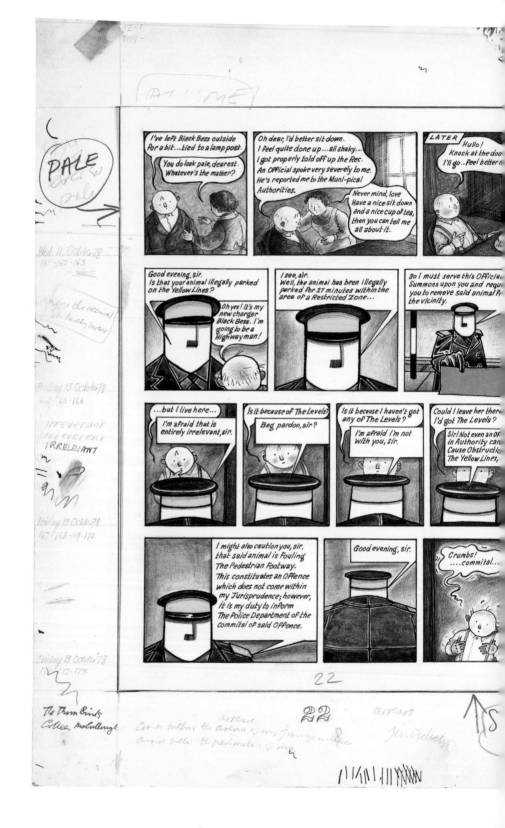

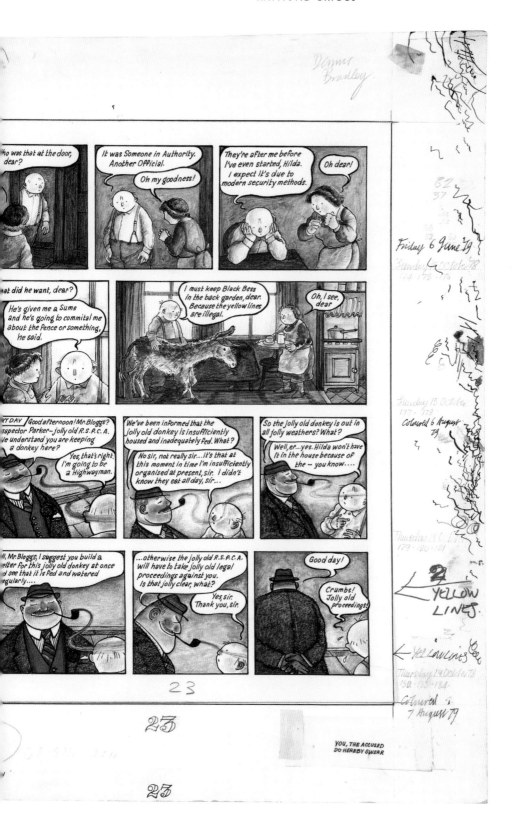

images reduce their faces to intimidating elements: a traffic warden's is blank but for a line for a nose and Hitler moustache; a judge is a nose protruding from a wig; an RSPCA representative dominates Jim with his 'jolly old' language and his encircling swirl of pipe smoke.

Briggs has spoken of his dislike of the 'piety and melodrama'[24] of Renaissance painting. He could draw (as *Gentleman Jim* shows) figures that look like Ingres or (as we see in *The Fairy Tale Treasury*) inhabit a curlicued rococo line like Aubrey Beardsley's, but he preferred the solidity of the peasants of Pieter Bruegel the Elder. His characters echo their dumpy shapes in books from *Gentleman Jim* onwards. (For years a poster of *Children's Games* decorated the wall of Briggs's studio.)

Jim and his wife, Hilda, reappear in *When the Wind Blows* (1982), and again they respect Authority. This book is about nuclear annihilation – the ultimate loss, brought close

Pieter Bruegel the Elder, *Children's Games*, 1560, Kunsthistorisches Museum, Vienna

by showing what happens to one ordinary married couple. It was published at a time of the resurgence of the Campaign for Nuclear Disarmament, when cruise missiles were in the news and women were camping in protest at RAF Greenham Common. The book is a satirical attack on the folly of governments, and their utterly inadequate published advice, which could not possibly save lives in the event of a nuclear strike. Jim and Hilda carefully obey official instructions before and after the bomb. Horrifyingly, all of it is real advice, as in the civil defence pamphlet 'Protect and Survive', published in 1980. Again Briggs has broken ground, by imagining the unimaginable, and balancing the tragedy with comedy – not least Hilda's uncomprehending determination to continue to observe social niceties and follow her domestic routine, which involves taking the washing in before the blast and putting her curlers in after, and applying Germolene antiseptic cream to radiation sores. When we say Raymond Briggs's work is poignant, it is not just sad. It is like a stab wound.

Briggs builds the threat with double-page images, in grey, that intersperse his comic-strip narrative. They show the build-up of weapons: the missile itself, warplanes, a nuclear submarine – the size and darkness of these illustrations contrasting with the tiny frames of Jim and Hilda's cosy home. The shift of scale is chilling. This is a Cold War book, with caricatures of Russian leaders, but as long as there are nuclear weapons in the world its tale is timely.

The most memorable image of all is a blank double-page spread with a hint of pink – a glow, a burn – at the edges. This is surely the most terrifying empty page in literature. Devastating in all senses, it shows the whiteness of a nuclear bomb exploding.

The final page is similarly minimal. All we see is the sloping door in the dark, under which the Bloggses believe they are safe, as invisible radiation takes them. The images are only varied by speech bubbles of their ill-informed attempts at prayer. Briggs offsets what we know with what his characters know. The book is shocking, but the illustration, as in *Fungus*, is understated. We watch scenes of ordinary domesticity, progressively losing colour, and we know this is a vision of the Apocalypse. We see drawings of

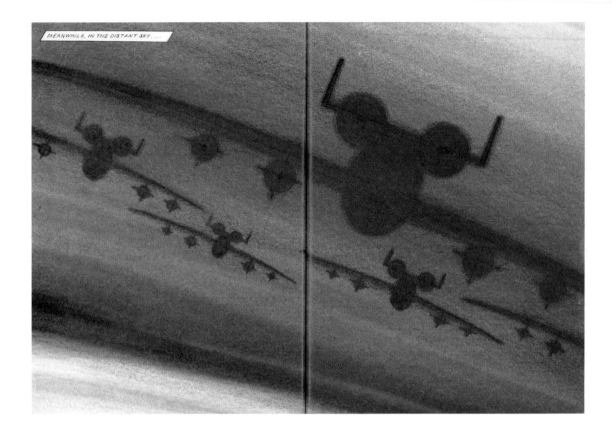

little, round, comic figures and understand they are tragic
heroes. We find the characters' ignorance funny, and they
break our hearts. The skill of such a balancing act, refined
in a lifetime of work, is Briggs's triumph.

Jim and Hilda were inspired by Briggs's parents, but his
parents, he says, were not so stupid. 'They would never have
shown such blind trust.'[25] Out of this book came political
demonstrations, a stage play, a radio play and an animated
film. The best the adaptations could do was to match the
power of the book.

Briggs's hardest-hitting satire could be surprisingly
subdued. But he was also capable, as we have seen, of visual
hyperbole. Briggs's grotesqueries were most unbridled
during the period when he worked without his longstanding
editor, Julia MacRae, who left Hamish Hamilton to set up
her own imprint. It was then that both *The Tin-Pot Foreign
General and the Old Iron Woman* (1984), about the British
conflict with Argentina over the Falkland Islands in 1982,

ABOVE
'Meanwhile in the distant sky…',
When the Wind Blows, 1982

OPPOSITE
'In just over three minutes…',
When the Wind Blows, 1982

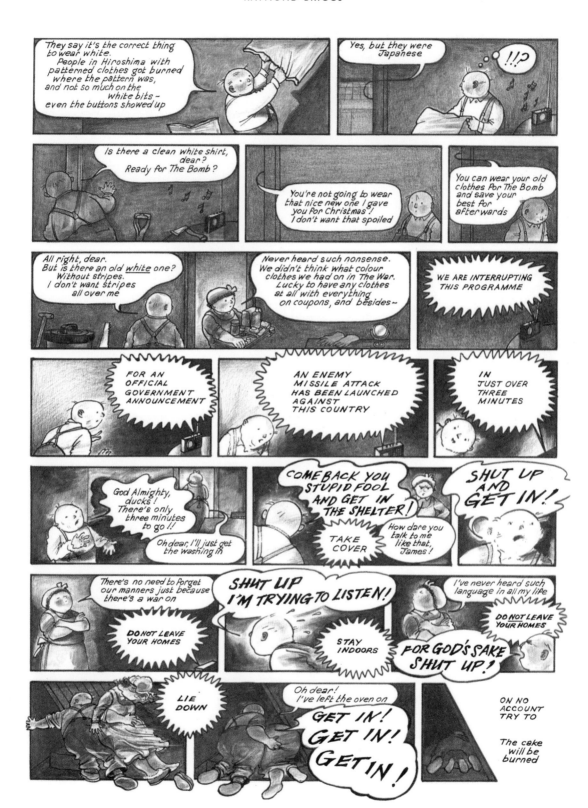

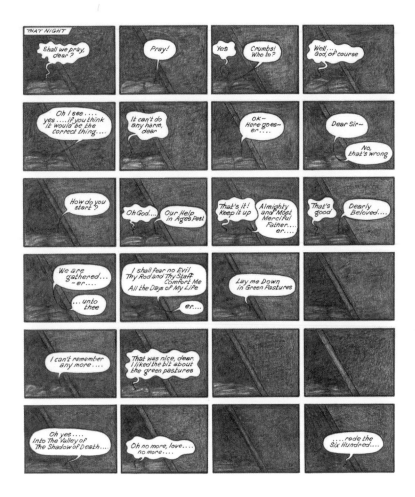

and the *Unlucky Wally* books (1987 and 1988) were published. MacRae was a moderating influence, and would, she says, have toned down the repulsive habits and sexual failures of Wally, and the crazed fury of Mrs Thatcher, shooting firepower from her breasts, and eroticized with a suspender belt.

What makes the Falklands book so powerful is the contrast between two styles: the fierce, extreme, angular caricatures of the warmongers and the shadowy, realistic, charcoal drawings of the victims of war. Briggs always represents anger by sensationalizing and pain by downplaying. He shifts from one to another with thunderous effect. And this time there are no jokes.

Briggs has called the *Unlucky Wally* books 'a self-indulgence'.[26] They are evidently an unkind self-portrait,

ABOVE
The last page of *When the Wind Blows*, 1982

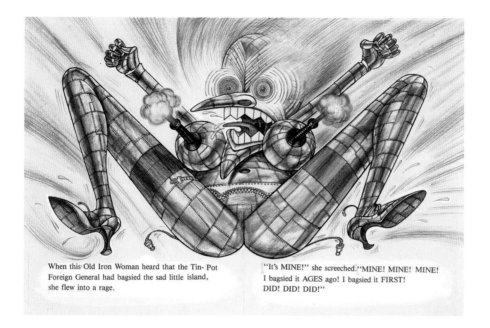

When this Old Iron Woman heard that the Tin-Pot Foreign General had bagsied the sad little island, she flew into a rage.

"It's MINE!" she screeched. "MINE! MINE! MINE! I bagsied it AGES ago! I bagsied it FIRST! DID! DID! DID!"

ABOVE

Artwork for a spread showing the Old Iron Woman, *The Tin-Pot Foreign General and the Old Iron Woman*, 1984

RIGHT

'Some men were shot...', *The Tin-Pot Foreign General and the Old Iron Woman*, 1984

If Wally swims in a lake, he usually finds the Frog Spawn.

Afterwards, there is always Tapioca for tea.

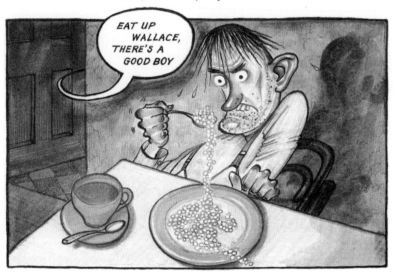

featuring an unattractive mummy's boy, their pitiless
pictures piling up evidence of misfortunes beyond
the text. He has claimed they were 'completely'
autobiographical – although Wally fails his army
medical, so that cannot be entirely true. The two
volumes, about the awkwardness of youth, including
sexual anxieties, and the indignities of ageing, show
a sad Everyman, for grown-ups to recognize.

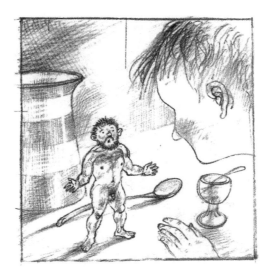

Uninvited guests

Briggs rejoined MacRae after her own list, launched in 1979, returned to the Random House stable in 1990. She reined in his later work, and under her governance Briggs returned to books that were more comfortable for a child audience. The first of these, *The Man* (1992), is about a boy who finds a naked homunculus on his bedside table and looks after him for several days. The Man is not cute. Unlike the snowman, he is no playmate. He is reactionary and plebeian, uttering racist insults, and a primitive survivor, on the margins of society, who is truculent because he has nothing and is forced to be parasitical. John, the boy, likes to read art books. The Man thinks this sissy; he follows sport. As in *Gentleman Jim*, authorities are busybodies and the Man makes John promise to keep him a secret, for fear of them.

We see the limitations of the liberal attitudes of the middle-class boy in *The Man* even if we share his shock at the boorish habits and prejudices of the little, older man he temporarily cares for. The boy finds when it is tested that his compassion has boundaries. Yet the book is still the story of the bond between them.

Chris Powling, who was a judge of the Kurt Maschler Award for an illustrated children's book, which *The Man* won, wrote: 'What Raymond Briggs does so well is invent mythical figures which remind us sharply of ourselves.'[27]

RIGHT
Full-frontal. Unused drawing for *The Man*, 1992

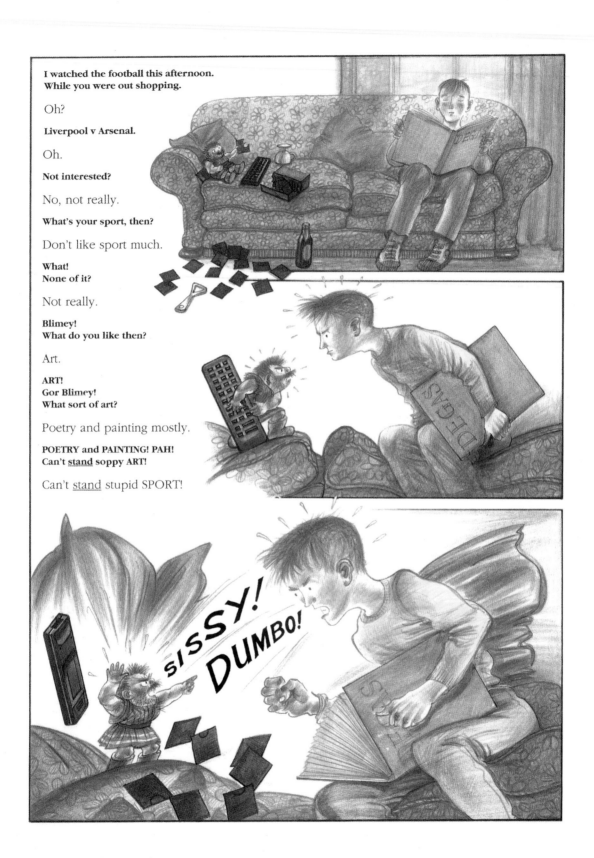

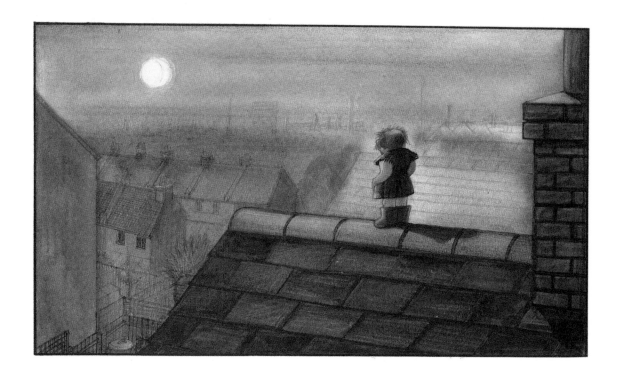

The book was inspired by Briggs thinking about carers and the demands that are made on them. Although the Man is rude and difficult, he and the boy have an affection for each other, and the frame in which the Man stands on a rooftop, looking out at a rising moon, transcends the playfulness and the arguments of the text, suggests loneliness, and strikes a poetic note. Briggs's talent for light and mood and atmosphere and composition is evident again.

After *The Man*, Briggs realized there was a subject he still had to address. 'Everyone has to do a bear book sooner or later,'[28] said Briggs, so he told a story of a little girl who takes care of an enormous polar bear. In 1994, a dot in the distance at Tilly's window drew progressively closer, frame-by-frame, and became *The Bear*. Briggs's is one of the largest, softest bears in children's fiction, a vast, radiant, downy creature rendered in pencil crayon and open cross-hatching. The grainy, soft-focus book is in a huge format, to envelop the reader in the feeling of its white fur, while a double-page spread suggests it fills the whole of a child's bedroom.

There is also wildness about this bear: one of the first details we see is its big black claws. This is Briggs's

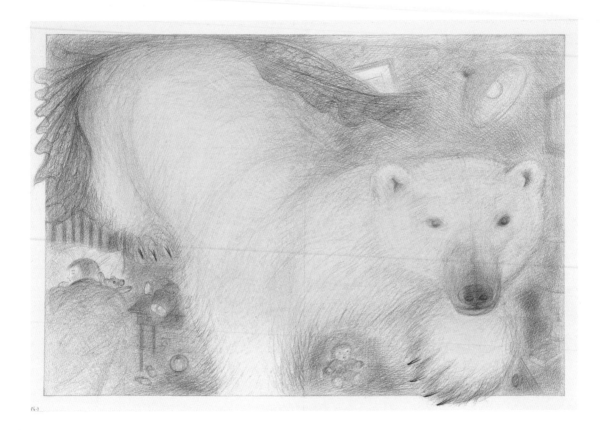

acknowledgment (after Sigmund Freud, quoted in the epigraph) that children accept all animals as equals. He also allows the child the upper hand. Adults don't believe in the bear, and Tilly and the audience are the ones in the know. The image in which Tilly sits on her father's knee, and he says: 'Golly, just imagine a great big bear in here now!' and the enormous bear lours over them as it stands behind the sofa, is superlative, and very satisfying for a child reader, who can see what the father does not.

Since this is a Briggs book, caring for the transient visitor is not without its difficulties. Tilly goes from telling the Bear 'I want you to stay with me for ever and ever', as she nestles on his sumptuous lap, to 'Oh, you BEAST!' when he wees on the floor. She needs help, but has adult incredulity to contend with. The only grown-up who goes along is Ernest Briggs, delivering milk to the door, who suggests a bear might need twenty pints of milk.

ABOVE
Bear filling a whole room. Artwork for *The Bear*, 1994

OPPOSITE
Bear behind the sofa. Artwork for *The Bear*, 1994

OVERLEAF
Mummy doubts, and Ernest Briggs believes in *The Bear*, 1994

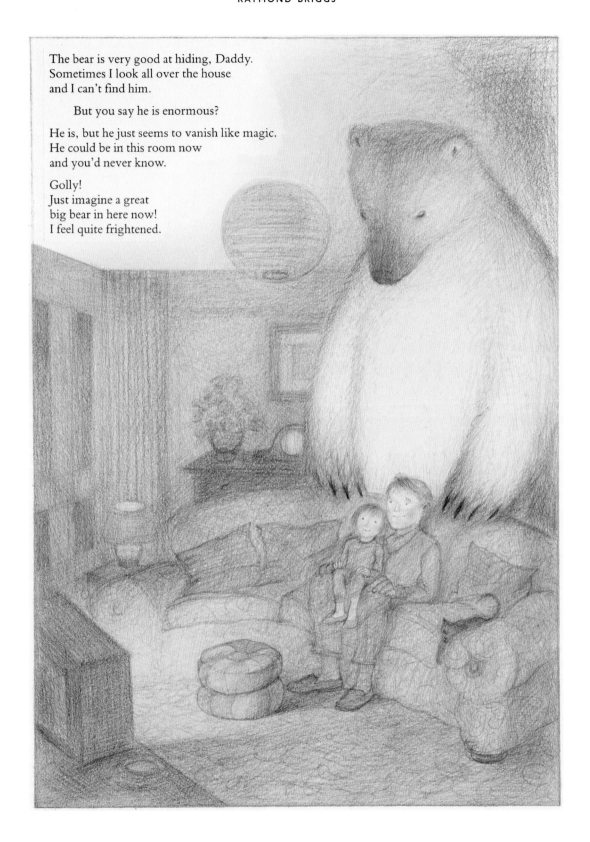

The bear is very good at hiding, Daddy.
Sometimes I look all over the house
and I can't find him.

But you say he is enormous?

He is, but he just seems to vanish like magic.
He could be in this room now
and you'd never know.

Golly!
Just imagine a great
big bear in here now!
I feel quite frightened.

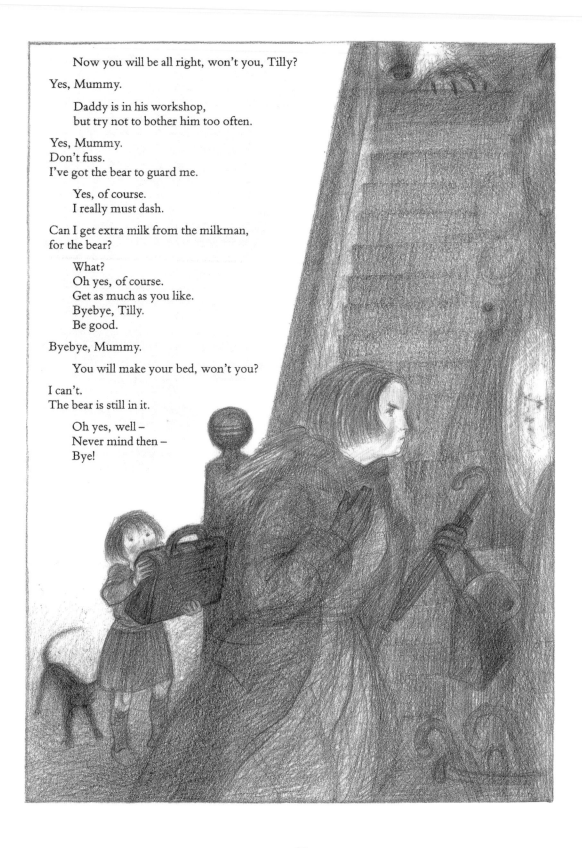

Now you will be all right, won't you, Tilly?

Yes, Mummy.

Daddy is in his workshop,
but try not to bother him too often.

Yes, Mummy.
Don't fuss.
I've got the bear to guard me.

Yes, of course.
I really must dash.

Can I get extra milk from the milkman,
for the bear?

What?
Oh yes, of course.
Get as much as you like.
Byebye, Tilly.
Be good.

Byebye, Mummy.

You will make your bed, won't you?

I can't.
The bear is still in it.

Oh yes, well –
Never mind then –
Bye!

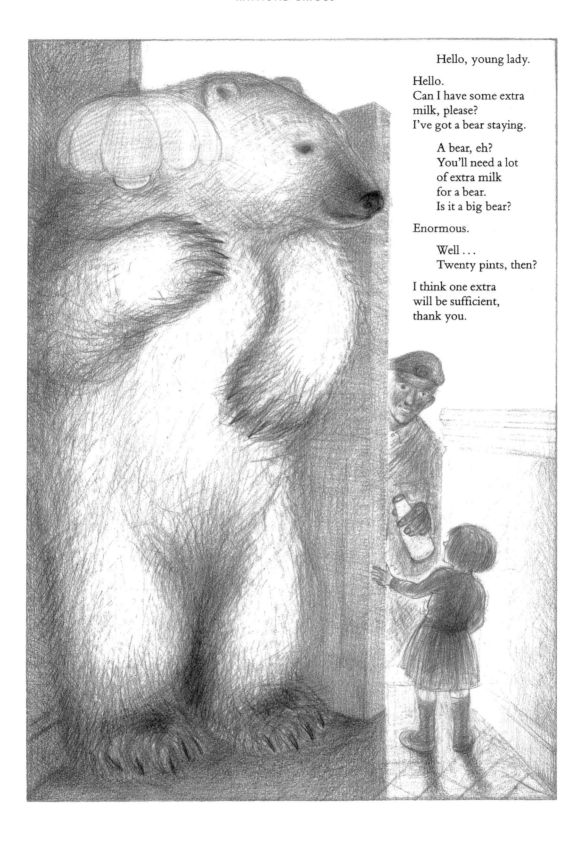

Hello, young lady.

Hello.
Can I have some extra milk, please?
I've got a bear staying.

A bear, eh?
You'll need a lot
of extra milk
for a bear.
Is it a big bear?

Enormous.

Well . . .
Twenty pints, then?

I think one extra
will be sufficient,
thank you.

Family histories

When Briggs's memoir of his parents' lives, from courtship to death, *Ethel & Ernest*, was published in 1998, it was the quintessence and the source of everything that had gone before. All the wonder, observation, humour and satire of previous books was born of Briggs's knowledge and love of his parents, and his exasperation with them. We see in this masterpiece the origin of the recurrent theme of characters who have very little education, which underlay *Jim and the Giant, Father Christmas, Fungus the Bogeyman, Gentleman Jim, When the Wind Blows* and *The Man*. We see where the apprehension of grief came from that was conveyed in *The Snowman, The Man, The Bear* and *The Tin-Pot Foreign General and the Old Iron Woman*. We discover that the old-fashioned domestic interiors with their 1930s details that had become a Briggs trademark, are

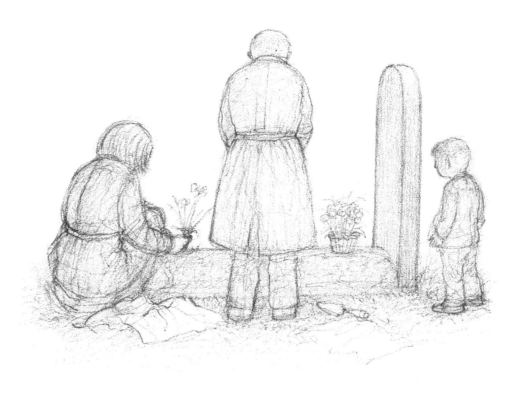

records of his childhood home. (Briggs, writing about the lack of appliances, let alone technology, in the homes of his youth, has called it 'Paradise Lost'.[29]) And the kind librarian in *Gentleman Jim*, whom Jim visualizes as his girlfriend in his fantasy of being a highwayman, seems to be a portrait of Jean. The distressing circumstances of Ethel's death, lying on a hospital trolley, with a box of Kleenex and a tin of Vim scouring powder by her face, had been seen in *Unlucky Wally: Twenty Years On*.

MacRae has said that Briggs's 'parents are with him every day',[30] and one critic rightly assessed *Ethel & Ernest* as 'the book Briggs was always trying to write'.[31] (MacRae was again a moderating influence on Briggs. She persuaded him to omit an image showing that the consummation on Ethel and Ernest's wedding night was painful and difficult. 'We did not know them well enough yet,'[32] says MacRae.)

The book uses so many of the skills we saw in other Briggs books, which had evolved to this point of perfection. It alternates the comic strip with larger set pieces of interiors and exteriors, so we see the full picture. It sets aside Briggs's penchant for caricature, and the images are understated, while the jokes are in the text. The exception is when joshing, tap-dancing Ernest plays the fool. Arguments are explosive, but mostly emotion is expressed quietly, as, for instance, showing Ernest's slumped distress at finding children's bodies in the Docklands during the Blitz. And it shows period detail with such diligent attention and painstaking love, with every texture worked and every background complete, that as a record of the times it is on a par with any contemporary art. This book is now used in schools as a chronicle of ordinary lives in the twentieth century.

Though he often espouses the simplicity of the comic strip, Briggs sustains a miniaturist's attention to detail. We see, for instance, the fabric of his mother's pinafore, the pattern on her curtains, and the decoration on her china, painstakingly repeated. Textures are built in layers, with circular pencil strokes.

Much of the comedy of the book comes from Ethel's perspective on domestic and international events. When told that 'if you're a Jew in Germany, you're forbidden to

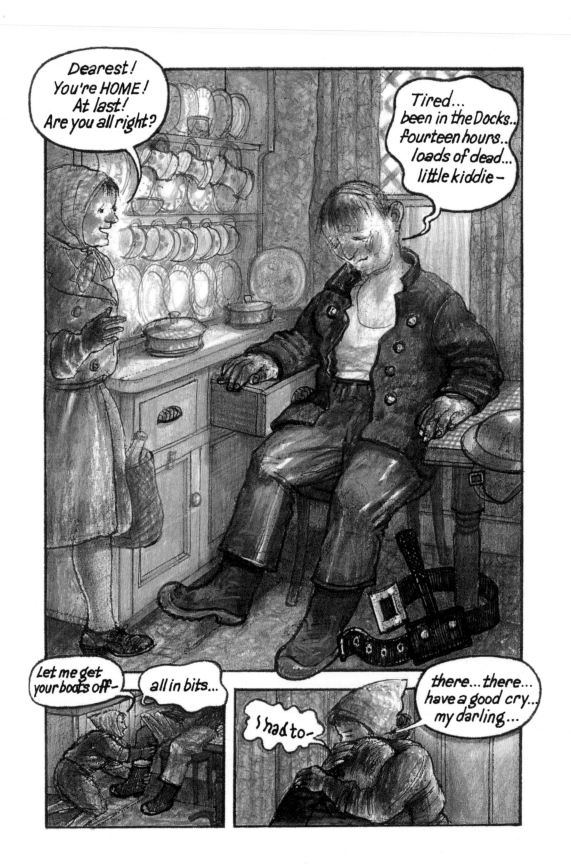

'marry a German', she says, missing the point splendidly, 'I'd hate to marry a German.' Although they lived below the bread line, Ethel, who had picked up airs from working in Belgravia, was outraged that she might be thought working class. She had a horror of the common. So, unlike her socialist husband and son, she voted Conservative, which she thought the party of the refined. When Ernest quotes Winston Churchill: 'Blood, toil, tears and sweat' Ethel is shocked. 'He wouldn't use words like that in his own home.'

Although the dialogue is rich and revealing and ironic and funny, sometimes the narrative is told in the images alone. The opening sequence of Ethel and Ernest's first encounter, with the shaken duster and the passing bicycle, for instance, which would have happened without words, and Ernest's demise through the seasons, in three frames, from first pains to collapse.

OPPOSITE

Ernest returns from duty in the Blitz, *Ethel & Ernest*, 1998

BELOW

Three frames show Ernest Briggs's months of decline, *Ethel & Ernest*, 1998

Poet and author Blake Morrison thought the book would have been a contender for the Booker Prize if it had not been true.[33]

At a screening of the animated film of *Ethel & Ernest* (2016), directed by Roger Mainwood and voiced by Brenda Blethyn and Jim Broadbent, Briggs was reduced to tears. He said: 'It was as if my parents were right there in the room.'[34]

Briggs had another flirtation with the idea of an education and generation gap with *Ug: Boy Genius of the Stone Age* (2001), set in a world where trousers and blankets are made of stone and everyone has hair like hedgehogs, and Ug longs for soft things, to the dismay of his parents.

Ug is cleverer than his parents, and his story is funny because we know how much ahead of his time he might have been if not stifled by their conservatism (he would have invented the wheel), but his book is about a family tie rather than a rebellion. It is even possible to argue that the affection of the parents trumps the cleverness of the boy.

'It is the same in all my books. You have the intelligent

BELOW
Ug invents the wheel. Artwork for *Ug: Boy Genius of the Stone Age*, 2001

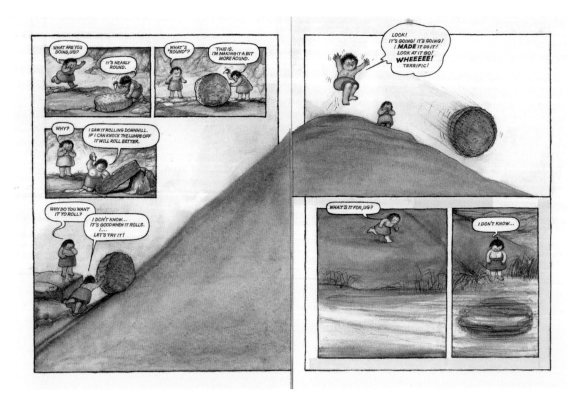

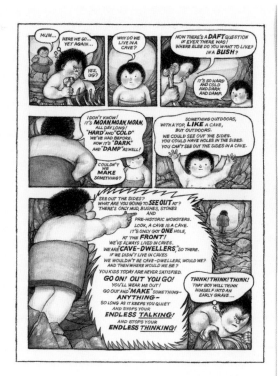

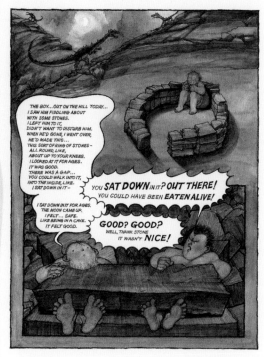

younger generation questioning the assumptions of a less
intelligent, less well-educated older generation.'[35] Although
it is mostly a *jeu d'esprit*, full of verbal and visual jokes, it
is also, like *Fungus* and *Gentleman Jim*, about unfulfilled
potential. In a bittersweet coda, we see Ug as an adult, and
that his cleverness and inventiveness changed nothing.

A publishers' suggestion at this point led to a surprising
detour. Twenty-eight years after he last did so, Briggs agreed
to illustrate someone else's text. He clearly found a kindred
spirit in the esteemed children's author Allan Ahlberg,
with the two books that followed, *The Adventures of Bert*
(2001) and *A Bit More Bert* (2002). These slapstick stories
of unfortunate mischances, featuring Bert, a dumpy, scruffy,
grown-up innocent, were irresistibly interactive, inviting
readers to wave, shush, catch a sweet or choose a flavour
of crisps. Mostly they are simple frames, with, unusually
for Briggs, white backgrounds, but occasionally he does his
atmospheric thing with weather and landscape. And, as
though Ethel is not yet worked out of his system, Briggs

ABOVE

Stone Age generation gap. Spread
from *Ug: Boy Genius of the Stone
Age*, 2001

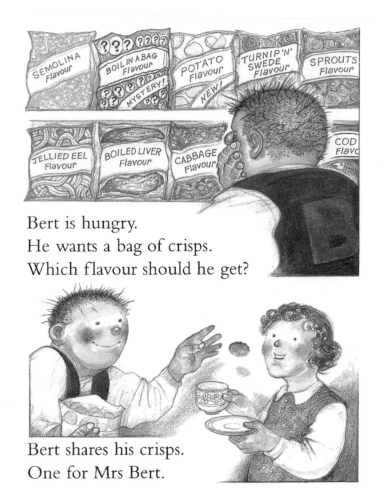

Bert is hungry.
He wants a bag of crisps.
Which flavour should he get?

Bert shares his crisps.
One for Mrs Bert.

draws both Mrs Bert and Grandma Bert with flowery pinnies and curly perms. The Bert books were designed by author and illustrator in a small format for small hands, but the publisher chose to issue them in a standard size, which makes the pages seem emptier than they should be, and does them a disservice.

In 2004, Briggs wrote, for the first time, a story based on his own experience that does not look back to his upbringing. *The Puddleman* sees him in his role as honorary grandfather, drawn, as usual, unflatteringly, with a spindly weediness, though the book is in pencil crayon, which we now associate with his most tender work. This is about a warm relationship

ABOVE
Bert shares his crisps, *A Bit More Bert*, 2002

OPPOSITE
Put-upon grandfather figure, *The Puddleman*, 2004

OVERLEAF
Holding a puddle, *The Puddleman*, 2004

between generations, even though the grandfather figure
is pulled along on a leash by the child. The book invents a
new mythical figure, who puts the water into puddles, and it
solves the unprecedented and tricky visual problem of how
you draw portable puddles. Briggs decided at a late stage that
the little boy, who had been drawn eighty-one times, should
be wearing Wellington boots instead of shoes. 'This meant

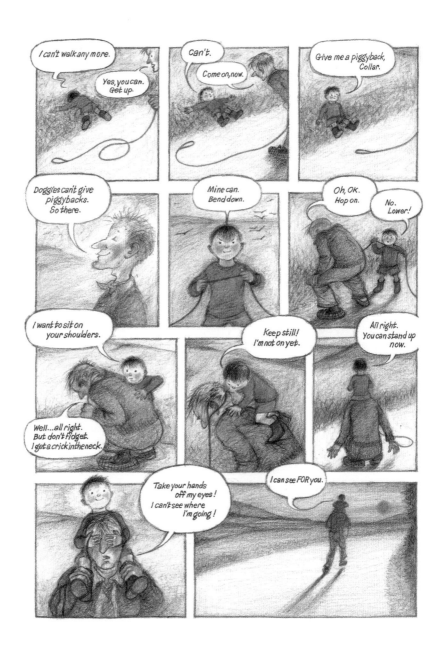

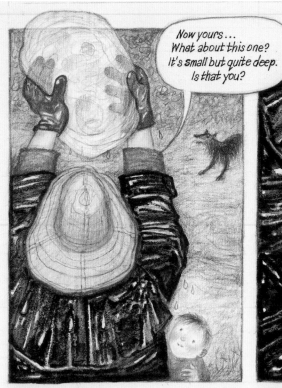

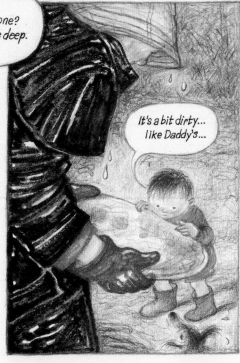

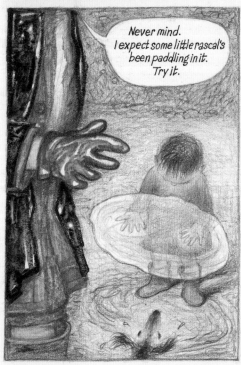

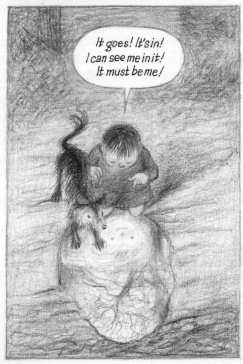

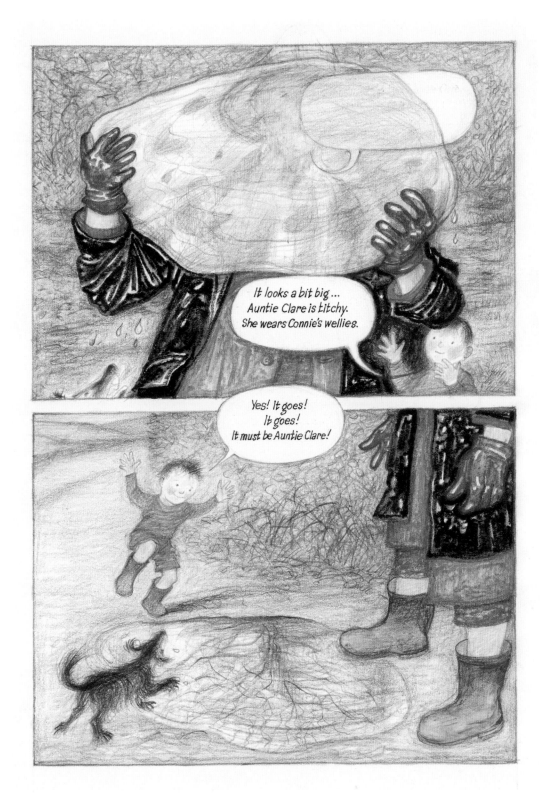

rubbing out 162 shoes and drawing 162 Wellingtons. After that, I thought he should be in shorts, not jeans, so 81 pairs of shorts had to be changed!'[36]

Briggs considers *The Puddleman* his last picture book, but he continued into 2018 to write and illustrate amusing reflections from his everyday life in columns for *The Oldie* magazine, some of which were collected, crowdfunded and published in 2015 under the title *Notes from the Sofa*. Each essay was followed by a small, uninhibited, scribbly pencil drawing.

A similar volume has appeared since. Briggs worked on a collection of short pieces during Liz's last years, when she was suffering from Parkinson's disease and dementia. Briggs devoted himself to her care until her death in October 2015.

These pieces, which are characteristically both humorous and elegiac, and painfully honest, are in prose and free verse and illustrated with pencil drawings (also comic and plaintive). The theme of the book is ageing and death, encompassing memories of Briggs's childhood and of his honorary grandchildren. The images, though still deft and controlled, look like the rough drafts for his picture books, including some in comic-strip form that recall *The Puddleman*. Occasionally the pencil line is so loose as to be only a suggestive scrawl, as if the drawing, like life, is falling apart.

The book is called *Time for Lights Out* (2019).

Briggs was elected a Fellow of the Royal Society of Literature in 1993. In 2017, he received the BookTrust Lifetime Achievement Award, and in the same year he was awarded a CBE for services to literature. It is a shame his mother did not live to see it. Raymond would certainly have made Ethel proud.

1. John Walsh, 'Raymond Briggs: Seasonal torment for The Snowman creator', *Independent*, 21 December 2012.
2. Raymond Briggs, words by Nicolette Jones, *Blooming Books*, Jonathan Cape in association with Puffin Books, 2003, p. 11.
3. Ibid., p. 63.
4. Ibid., p. 12.
5. Nicholas Wroe, 'Bloomin' Christmas', *The Guardian*, 18 December 2004.
6. John Walsh, 'Graphic novelist Raymond Briggs appeals to the British public for help with his next project', *Independent*, 7 February 2015.
7. *Blooming Books*, op. cit., p. 13.
8. Raymond Briggs, 'My Writing Day': 'Raymond Briggs: "Fungus the Bogeyman took two years. The Snowman was light relief"', *The Guardian*, 11 March 2017.
9. Briggs quoted in Wroe, 'Bloomin' Christmas', *The Guardian*, 18 December 2004 and in Walsh, 'Raymond Briggs: Seasonal torment for The Snowman creator', *Independent*, 21 December 2012.
10. http://arts.brighton.ac.uk/alumni-arts/briggs,-raymond

11. *Blooming Books*, op. cit., p. 12.
12. Sarah Hughes, 'Raymond Briggs: "Don't call me the king of Christmas. I don't like children, I try to avoid them"', *The Observer*, 20 December 2015.
13. *Blooming Books*, op. cit., p. 13.
14. Ibid., p. 52.
15. Ibid., p. 56.
16. Ibid., p. 57.
17. Ibid.
18. Briggs, 'My Writing Day': 'Raymond Briggs: "Fungus the Bogeyman took two years. The Snowman was light relief"', *The Guardian*, 11 March 2017.
19. Hughes, 'Raymond Briggs: "Don't call me the king of Christmas. I don't like children, I try to avoid them"', *The Observer*, 20 December 2015.
20. Walsh, 'Graphic novelist Raymond Briggs appeals to the British public for help with his next project', *Independent*, 7 February 2015.
21. From Briggs's annotated first edition of *The Snowman*, sold at auction for £12,000 at Sotheby's in London on 8 December 2014, in aid of the House of Illustration.
22. Charlotte Eyre, 'Illustrators recreate The Snowman for 40th anniversary

exhibition', *The Bookseller*, 3 December 2018.
23. *Blooming Books*, op. cit., p. 105.
24. *Blooming Books*, op. cit., p. 165 and Wroe, 'Bloomin' Christmas', *The Guardian*, 18 December 2004.
25. *Blooming Books*, op. cit., p 223.
26. Ibid., p. 190.
27. Chris Powling, 'The Man behind THE MAN', *Books for Keeps*, 76, September 1992.
28. *Blooming Books*, op. cit., p. 116.
29. Raymond Briggs, 'No fridge, no freezer, no flush, no fone ...', *Notes from the Sofa*, Unbound, 2015, p. 12.
30. Wroe, 'Bloomin' Christmas', *The Guardian*, 18 December 2004.
31. *Blooming Books*, op. cit., p. 276.
32. Ibid., p. 283.
33. Walsh, 'Raymond Briggs: Seasonal torment for *The Snowman* creator', *Independent*, 21 December 2012.
34. Decca Aitkenhead, 'Raymond Briggs: "There could be another world war. Terrifying, isn't it?"', *The Guardian*, 24 December 2016.
35. *Blooming Books*, op. cit., p. 204.
36. Raymond Briggs, 'Why I'd like to be a proper author', *The Guardian*, 2 November 2002.

SELECT BIBLIOGRAPHY

Books written or illustrated by Raymond Briggs

The Adventures of Bert, Allan Ahlberg, Puffin Books, 2001
The Bear, Julia MacRae Books, 1994
A Bit More Bert, Allan Ahlberg, Puffin Books, 2002
The Christmas Book, edited by James Reeves, Heinemann, 1968
Collected Poems for Children, Ted Hughes, Faber and Faber, 2005
Danger on Glass Island, Alan Ross, Hamish Hamilton, 1960
The Elephant and the Bad Baby Elfrida Vipont, Hamish Hamilton, 1969
Ethel & Ernest: A True Story, Jonathan Cape, 1998
The Fair to Middling, Arthur Calder-Marshall, Penguin, 1962
The Fairy Tale Treasury, edited by Virginia Haviland, Hamish Hamilton, 1972

Father Christmas, Hamish Hamilton, 1973
Father Christmas Goes on Holiday, Hamish Hamilton, 1975
Fee Fi Fo Fum: A Picture Book of Nursery Rhymes, Hamish Hamilton, 1964
Festivals, edited by Ruth Manning-Sanders, Heinemann, 1972
First Up Everest, Showell Styles, Hamish Hamilton, 1969
The Flying 19, James Aldridge, Hamish Hamilton, 1966
The Forbidden Forest and Other Stories, James Reeves, Heinemann, 1973
Fungus the Bogeyman, Hamish Hamilton, 1977
The Fungus the Bogeyman Plop-Up Book, Hamish Hamilton, 1982
Gentleman Jim, Hamish Hamilton, 1980

The Hamish Hamilton Book of Giants, edited by William Mayne, Hamish Hamilton, 1968
The Hamish Hamilton Book of Magical Beasts, edited by Ruth Manning-Sanders, Hamish Hamilton, 1965
The Hamish Hamilton Book of Myths and Legends, edited by Jacynth Hope-Sympson, Hamish Hamilton, 1964
Jim and the Beanstalk, Hamish Hamilton, 1970
Jimmy Murphy and the White Duesenberg, Bruce Carter, Hamish Hamilton, 1968
Lindbergh the Lone Flyer, Nicholas Fisk, Hamish Hamilton, 1968
Look at Castles, Alfred Duggan, Hamish Hamilton, 1960
Look at Churches, Alfred Duggan, Hamish Hamilton, 1961
The Man, Julia MacRae Books, 1992

Midnight Adventure, Hamish Hamilton, 1961

The Missing Scientist, Sydney Frank Stevens, OUP, 1959

The Mother Goose Treasury, Hamish Hamilton, 1966

Notes from the Sofa, Unbound, 2015

Nuvolari and the Alfa Romeo, Bruce Carter, Hamish Hamilton, 1968

The Onion Man, Alan Ross, Hamish Hamilton, 1959

Peter and the Piskies: Cornish Folk and Fairy Tales, Ruth Manning-Sanders, OUP, 1958

Peter's Busy Day, A. Stephen Tring, Hamish Hamilton, 1959

Poems for Me, Books 4 & 5, Kit Patrickson, Ginn, 1968

The Puddleman, Jonathan Cape, 2004

Richthofen the Red Baron, Nicholas Fisk, Hamish Hamilton, 1958

Ring-a-Ring o' Roses, Hamish Hamilton, 1962

Shackleton's Epic Voyage, Michael Brown, Hamish Hamilton, 1969

Sledges to the Rescue, Hamish Hamilton, 1963

The Snowman, Hamish Hamilton, 1978

The Snowman Pop-Up Book (with music), with Ron van der Meer, Hamish Hamilton, 1985

Stevie, Elfrida Vipont, Hamish Hamilton, 1965

The Strange House, Hamish Hamilton, 1961

The Study Book of Houses, Clifford Warburton, Bodley Head, 1963

The Swan Princess (unattributed text), Nelson, 1964

The Tale of Three Landlubbers, Ian Serraillier, Hamish Hamilton, 1970

This Little Puffin: Finger Plays and Nursery Games, edited by Elizabeth Matterson, chapter-head illustrations by Raymond Briggs, decorations by David Woodruffe, Penguin Books, 1969

The Time of Your Life: Getting On with Getting On, edited by John Burningham, essay by Raymond Briggs, Bloomsbury, 2003

Time for Lights Out, Jonathan Cape, 2019

The Tin-Pot Foreign General and the Old Iron Woman, Hamish Hamilton, 1984

Ug: Boy Genius of the Stone Age, Jonathan Cape, 2001

Unlucky Wally, Hamish Hamilton, 1987

Unlucky Wally Twenty Years On, Hamish Hamilton, 1988

The Way Over Windle, Mabel Esther Allan, Methuen, 1966

When the Wind Blows, Hamish Hamilton, 1982

When the Wind Blows (play, adapted by Raymond Briggs, unillustrated), Samuel French, 1983

Whistling Rufus, William Mayne, Hamish Hamilton, 1964

The White Land, Hamish Hamilton, 1963

William's Wild Day Out, Meriol Trevor, Hamish Hamilton, 1963

The Wonderful Cornet, Barbara Ker Wilson, Hamish Hamilton, 1958

The Wreck of Moni, Alan Ross, Hamish Hamilton, 1965

Books to which Raymond Briggs contributed

All in a Day, edited by Mitsumasa Anno, Hamish Hamilton, 1986; one of ten international illustrators, Briggs contributed eight spreads about a boy called James on a snowy day

Related books

Blooming Books, anthology of the work of Raymond Briggs, with commentary by Nicolette Jones, Jonathan Cape in association with Puffin Books, 2003

The Snowman: A new story inspired by the original tale by Raymond Briggs, Michael Morpurgo, illustrated by Robin Shaw, Puffin Books, 2018

The World of English Picture Books, edited by Ikuko Motoki, Korinsha Press, 1998

Newspaper and magazine articles by or about Raymond Briggs

Aitkenhead, Decca, 'Raymond Briggs: "There could be another world war. Terrifying, isn't it?"', *The Guardian*, 24 December 2016

Barnett, Laura, 'How I made: Raymond Briggs on Father Christmas', *The Guardian*, 16 December 2014

Briggs, Raymond, 'Why I'd like to be a proper author', *The Guardian*, 2 November 2002

—, 'Raymond Briggs: "Fungus the Bogeyman took two years. The Snowman was light relief"', *The Guardian*, 11 March 2017

Carey, Joanna, 'Drearly Beloved', *The Guardian*, 6 December 2003

Christmas, Linda, 'Raymond Briggs: Coming clean with the snowman', *The Guardian*, 7 September 1978; republished 'From the Guardian Archive', 7 September 2016

Cooke, Rachel, 'Big kid, "old git" and still in the rudest of health', *The Observer*, 10 August 2008

Dowling, Tim, 'Raymond Briggs: Snowmen, Bogeymen & Milkmen review – a timely look at an eccentric life', *The Guardian*, 31 December 2018

Flood, Allison, 'Raymond Briggs's final book, which faces death "head-on", due this year', *The Guardian*, 27 February 2019

Hughes, Sarah, 'Raymond Briggs: "Don't call me the king of Christmas. I don't like children, I try to avoid them"', *The Observer*, 20 December 2015

Jack, Ian, 'Portrait of the artist as an Englishman', Notebook, *Independent*, 3 October 1998

Powling, Chris, 'The Man behind THE MAN', *Books for Keeps*, 76, September 1992

Rhind-Tutt, Louise, '"I was against the Snowman being associated with Christmas at first": Raymond Briggs on a career creating iconic children's characters', *inews*, 4 December 2017 (updated 6 September 2019)

Secher, Benjamin, 'Raymond Briggs: "I don't believe in happy endings"', *The Telegraph*, 24 December 2007

Walsh, John, 'Raymond Briggs: Seasonal torment for The Snowman creator', *Independent*, 21 December 2012

—, 'Graphic novelist Raymond Briggs appeals to the British public for help with his next project', *Independent*, 7 February 2015

Webber, Richard, 'Raymond Briggs: "I'm not a fan of Christmas. It's a great fuss about nothing"', *The Guardian*, 19 December 2014

Wroe, Nicholas, 'Bloomin' Christmas', *The Guardian*, 18 December 2004

1934 18 January, Raymond Redvers Briggs born in Wimbledon, the only child of Ethel (née Bowyer), former lady's maid, and Ernest Briggs, milkman

1939 Evacuated briefly to stay with his aunts Flo and Betty in Dorset

1945 Wins scholarship to Rutlish Grammar School

1949–1953 Studies painting at Wimbledon School of Art

1953 Studies typography at Central School of Art

1953–1955 Draughtsman in the Royal Corps of Signals as part of his National Service

1955–1957 Attends Slade School of Fine Art (University College London)

1957 Begins work as professional illustrator

1958 First illustrated book published: *Peter and the Piskies*

1961 *Midnight Adventure* and *The Strange House*, the first of his own authored books, are published

1961 Buys house in Westmeston, Hassocks, Sussex

1961 Begins to teach illustration part-time at Brighton School of Art, which he continues until 1986

1963 Marries Jean Taprell Clark

1964 Publication of *Fee Fi Fo Fum*, which is commended for the Kate Greenaway Medal

1966 Publication of *The Mother Goose Treasury*, which wins the Kate Greenaway Medal

1969 Publication of *The Elephant and the Bad Baby*

1971 His mother, Ethel, dies. Nine months later his father, Ernest, dies of stomach cancer

1973 His wife, Jean, dies of leukaemia

1973 Publication of *Father Christmas*, which wins Briggs his second Kate Greenaway Medal

1974 Travels to France, Scotland and the American Library Association Conference in Las Vegas

1975 Publication of *Father Christmas Goes on Holiday*

c. 1975 Meets Liz who becomes his partner for forty years

1977 Publication of *Fungus the Bogeyman*

1978 Publication of *The Snowman*

1979 *The Snowman* wins the Boston Globe-Horn Book Award in the US, the Silver Pen Award (Netherlands), Premio Critici in Erba (Italy)

1980 Publication of *Gentleman Jim*

1982 Publication of *When the Wind Blows*

1982 Animated film of *The Snowman* shown on Channel 4. Wins BAFTA for best children's programme (entertainment/drama)

1983 BBC *Omnibus* TV documentary is followed the next day by Briggs's dramatization for radio of *When The Wind Blows,* with Peter Sallis and Brenda Bruce, which wins the Broadcasting Press Guild award for best radio programme

1983 April, play of *When the Wind Blows* opens in the West End at the Whitehall Theatre, starring Ken Jones and Patricia Routledge

1983 Castaway on BBC Radio 4's *Desert Island Discs* with Roy Plomley

1984 David Bowie records an introduction to *The Snowman* animated film

1984 Publication of *The Tin-Pot Foreign General and the Old Iron Woman*

1985 Aled Jones tops the charts with Howard Blake's song 'Walking in the Air'

1986 Animated film based on *When the Wind Blows*, voiced by Peggy Ashcroft and John Mills

1991 Animated film of *Father Christmas,* with Mel Smith

1992 Publication of *The Man,* which wins the Kurt Maschler Award

1992 Children's Author of the Year at the British Book Awards

1993 Elected a Fellow of the Royal Society of Literature

1994 Publication of *The Bear*

1997 Stage show of *The Snowman* opens at Peacock Theatre, London

1998 Publication of *Ethel & Ernest: A True Story*. It wins Illustrated Book of the Year at the British Book Awards

1998 Animated film of *The Bear*

1998–99 Japanese touring exhibition of 'The World of English Picture Books'. Briggs visits Japan with other featured illustrators in 1998

2001 Publication of *Ug: Boy Genius of the Stone Age,* which wins a Silver Medal in the Smarties Awards, voted for by children

2003 Images from *The Snowman* appear on the Isle of Man's 50 pence coin, including the first ever colour image on a coin

2003 Publication of *Blooming Books*, an anthology and study of Briggs's work (text by Nicolette Jones)

2004 Publication of *The Puddleman*

2004 Animated film of *Fungus the Bogeyman*

2004 Royal Mail issues set of *Father Christmas* stamps

2005 Limited edition of Royal Mail stamps with drawings from *The Snowman* issued for Childline's 20th anniversary

2005 Castaway on BBC Radio 4's *Desert Island Discs* with Sue Lawley

2005 For the 50th anniversary of the Carnegie Medal (1955–2005), *Father Christmas* (1973) is named one of the top-ten best winners

2008 Contributor to *Picture Book*, three-part Channel 4 documentary about children's books (Episode 2: *Now We Are Six*)

2012 Christmas Eve, the 30th anniversary of *The Snowman* marked by a sequel, *The Snowman and the Snowdog,* on Channel 4, accompanied by a documentary about Briggs: *How the Snowman Came Back to Life*

2012 Briggs is the first person to be inducted into the British Comic Awards Hall of Fame

2014 Receives the Phoenix Picture Book Award from the Children's Literature Association for *The Bear* (1994)

2015 October, Liz dies after suffering for years from Parkinson's disease

2015 Publication of crowdfunded *Notes from the Sofa*

2015 Three-part live action Sky TV mini-series of *Fungus the Bogeyman* with Timothy Spall as Fungus and Victoria Wood as Eve, a 'Drycleaner'

2016 Animated film of *Ethel & Ernest,* voiced by Brenda Blethyn and Jim Broadbent shown on BBC One

2017 February, wins BookTrust Lifetime Achievement Award for children's literature

2017 June, awarded a CBE in the Queen's Birthday Honours

2018 40th anniversary celebrations of *The Snowman*. Other illustrators produce their own versions and the pictures, along with Briggs's original drawings, are exhibited in Brighton and raise £10,000 for a Sussex children's hospice

2018 31 December, TV documentary *Raymond Briggs: Snowmen, Bogeymen & Milkmen* shown on BBC Two

2019 Publication of *Time for Lights Out*

Raymond Briggs has shown enormous generosity in giving permission for the use of his work, as well as patience, both now and when we last worked together, sixteen years ago, with all questions, demands and intrusions, allowing us the privilege of going through the treasures in the attics and cupboards of two houses. I am very grateful, too, to Raymond's family, and to his assistant Sue Thomson, who made so much of this possible.

Thanks to publishers Roger Thorp, Amber Husain and Julia MacKenzie at Thames & Hudson for their enthusiastic, skilful and diligent care of this project. To Therese Vandling for her design. And also to Claudia Zeff, such a sensitive editor, and a great expedition companion to Plumpton and Westmeston. Similarly, Olivia Ahmad of the House of Illustration, who shared both the adventure and her expertise, and who has preserved so much of Raymond's original work for the future, with her colleagues at the House of Illustration Marina Inoue and Kate Nairne.

I am glad of the skill of photographer Justin Piperger, who took the pictures of Raymond's artwork.

And I am obliged to Raymond's editor, Julia MacRae, his fellow artists Posy Simmonds, Steve Bell and Chris Riddell, and critics John Walsh, Ian Jack, Philip Hensher, Blake Morrison and Chris Powling for their research and their perceptive observations about Raymond and his work.

Thanks are due, too, to Raymond's publisher, now Penguin Random House, for the use of material, as well as to Julia MacRae Books and Unbound for the same, and to literary agent Hilary Delamere, who smoothed the contractual path.

Personally, I am indebted to Abigail Sparrow and Philippa Perry of the SP Agency, my incomparable, creative agents. And to Nicholas, Rebecca and Laura Clee, who are, in every possible way, 'triffic'.

CREDITS

Unless otherwise credited, all artworks are © Raymond Briggs and are reproduced by kind permission of Raymond Briggs.

Pages 4, 8, 11, 19, 20(a&b), 24, 26(a), 27(a), 31, 32, 33(l&r), 34(a&b), 35, 36, 37, 38(a&b), 39, 40–41, 42–43, 44, 45, 46–47, 49(a&b), 50, 52, 54–55, 56, 58, 59, 68, 77, 78–79, 85(a), 90, 91, 98, 99, 102, 103 photography Justin Piperger.

Page 14: Jean-Siméon Chardin, *The Young Schoolmistress*, *c.* 1737. Oil on canvas, 61.6 × 66.7 cm (24⅜ × 26⅜ in.). National Gallery, London; page 25 Diego Velázquez, *Portrait of Mariana of Austria*, 1652–53. Oil on canvas, 234.2 × 132 cm (92¼ × 52 in.). Museo del Prado, Madrid; page 80 Pieter Bruegel the Elder, *Children's Games*, 1560. Oak panel, 116.4 × 160.3 cm (45⅞ × 63⅛ in.). Kunsthistorisches Museum, Vienna; page 105 photograph © Jonathan Brady.

Artwork from *Ethel and Ernest* by Raymond Briggs published by Jonathan Cape. Reproduced by permission of The Random House Group Ltd. © Raymond Briggs 1999. Artwork from *Gentleman Jim* by Raymond Briggs published by Jonathan Cape. Reproduced by permission of The Random House Group Ltd. © Raymond Briggs 2008. Words reprinted from *A Bit More Bert* by Allan Ahlberg and Raymond Briggs (Puffin Books, 2002). © Allan Ahlberg 2002.

CONTRIBUTORS

Nicolette Jones is a writer, critic and broadcaster who has been the children's books editor of the *Sunday Times* for more than two decades, and collaborated with Raymond Briggs on an anthology of his work, *Blooming Books*, published in 2003. She also wrote the award-winning *The Plimsoll Sensation: The Great Campaign to Save Lives at Sea* (a Radio 4 Book of the Week), and compiled *Writes of Passage: 100 Things To Read Before You Turn 13* (2020). She was a Henry Fellow as a graduate student at Yale, and has been a Royal Literary Fund Fellow at UCL and King's College London. Her father, like Briggs, was an artist and teacher who studied Fine Art at the Slade. www.nicolettejones.com

Quentin Blake is one of Britain's most distinguished illustrators. For twenty years he taught at the Royal College of Art where he was head of the illustration department from 1978 to 1986. Blake received a knighthood in 2013 for his services to illustration and in 2014 was admitted to the Légion d'honneur in France.

Claudia Zeff is an art director who has commissioned illustration for book jackets, magazines and children's books over a number of years. She helped set up the House of Illustration with Quentin Blake where she is now Deputy Chair. Since 2011 she has worked as Creative Consultant to Quentin Blake.

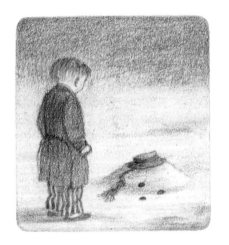